Rebel Jester Mystic Poet

CONTEMPORARY PERSIANS

Rebel Jester Mystic Poet

CONTEMPORARY PERSIANS

Fereshteh Daftari

Works from the
Mohammed Afkhami Collection
Exhibited at the Aga Khan Museum

AGA KHAN MUSEUM

black dog
publishing
london uk

Foreword

For more than a generation, the name "Iran" has been inextricably linked to strife—internally, regionally and internationally. The perception of Iran and Iranians in the West has been constricted by limited media coverage, turbulent political events and travel restrictions, oblivious to a people who live contemporary lives, are passionate about the arts and are deeply proud of their cultural legacy. It misses out on a thriving contemporary arts scene as well as glossing over the substantial population of Iranians who have lived abroad for decades and who are forging their own identities, which, while new, are still linked to their homeland. The purpose of this exhibition is to shed light on the identity of Iranians today by examining the art that has been created by Iranian artists practising both inside and outside the country. The subtitle *Contemporary Persians* was deliberately chosen to denationalize the issue and to allow for a greater consideration of who Persians are today, living in dozens of countries worldwide.

The art featured in *Rebel, Jester, Mystic, Poet: Contemporary Persians* confronts topical issues such as gender, politics and religion—issues familiar to those in the Western world—through quiet rebellion, humour, mysticism and poetry. Through an exceptional array of pieces ranging from sculpture to video, the works selected present a different side of Iran, one previously unseen by Canadian audiences, and yet very familiar in its medium and meaning. Together, the varied works are representative of contemporary generations, diverting associations with common perceptions of the region and embracing a shifting, prospective identity.

The Aga Khan Museum wishes to thank Dr. Fereshteh Daftari for her valuable insight in helping the Museum to curate this extraordinary exhibition. It also wishes to extend its gratitude to Mohammed Afkhami and the Mohammed Afkhami Collection, one of the most important collections of contemporary Iranian art today, which presents an alternate archive of Iranian history—a history now illuminated at the Aga Khan Museum.

Henry S. Kim
Director and CEO, Aga Khan Museum

Preface

When I started collecting Iranian modern and contemporary art over 12 years ago, my aspiration was simply to buy works that had an aesthetic appeal and resolve a nostalgic connection that I felt for Iran having left the country at a very young age. As I explored the depths of this vibrant art scene, I came to the realization that Iran's greatest wealth and contribution to the world has been its rich cultural heritage.

Today the Middle East is engulfed in political turmoil with the only images beamed into global households being those of violence. This perspective should be balanced with a more positive narrative and specifically by the artworks that highlight a thriving cultural scene, evidenced by the explosion of galleries in Tehran and Dubai exhibiting Iranian artists and highlighting the international triumphs achieved by Iranian film. To this end, I am continuing the tradition that was started by my late maternal grandfather, Senator Mohammad Ali Massoudi, and my mother Maryam Massoudi, who between 1940 and 1979 amassed a recognized pre-Islamic to modern Iranian art collection that was set to be exhibited both within Iran and abroad before those plans were interrupted by the Iranian Revolution of 1979.

As Iran enters a new chapter in its relationship with the rest of the world, it is a great honour that the Aga Khan Museum has given this exceptional platform to display a selection of contemporary Iranian artworks from my collection and I am indebted to our curator, Fereshteh Daftari, and all of Iran's very talented artists whose support has made this possible.

Mohammed Afkhami

Rebel, Jester, Mystic, Poet: Contemporary Persians

Fereshteh Daftari

Rebel, Jester, Mystic, Poet: Contemporary Persians

Fereshteh Daftari

Mohammed Afkhami's collection offers an entry point into the contemporary art of a nation known to foreigners, since the ancient Greeks, as Persia, but whose indigenous name has always been Iran. Reza Shah Pahlavi (r. 1925–1941), who had embarked on a modernization project, associated "Persia" and the Qajar dynasty he had supplanted with decadence. In 1935, he instructed all foreign governments to use "Iran"—meaning the land of Aryans (at the time a loaded and strategic identity)—rather than Persia, which, in any case, referred only to Fars, one of the nation's provinces.[1] With the 1979 Revolution (also known as the Iranian or Islamic Revolution) and the demise of the Pahlavi regime, then headed by Mohammad Reza Shah (r. 1941–1979), the country was officially renamed the Islamic Republic of Iran. The Persia-vs-Iran saga took a further twist in the contemporary moment: with the takeover of the US embassy in Tehran and the capture of 52 American hostages in the fall of 1979—events that led to Iran's characterization as a rogue nation in the Western media—Iranians abroad adopted "Persian" as a preferred marker of self-identification. The term diverted association with the Islamic regime of Iran, recalled an ancient civilization, and shielded the diasporic population (or so they hoped) from contempt, even discrimination. Such subterfuge is a strategy Iranians have often resorted to in the course of a history that has not been immune to ruthless foreign invaders and repressive local autocrats. As intimated in *Rebel, Jester, Mystic, Poet: Contemporary Persians*, in the new millennium, the time period that is the focus of the exhibition, Iranian artists have continued to make use of the strategies of survival widespread in their culture: veiled critique or the politics of ruse and cunning, poetic flights, humour and satire, and a path of mysticism distinct from organized religion.[2] In the next chapter, Professor Ahmad Karimi-Hakkak expounds on similar traits in Iranian literature.

A passion for the arts of Iran, tinged with patriotic overtones, is part of Mohammed Afkhami's family history, a legacy that began with his maternal grandfather, Mohammad Ali Massoudi. As early as the 1940s, Massoudi—editor-in-chief of the newspaper *Ettela'at*, subsequently a member of

15

parliament, and then a senator—began cultivating an important collection that grew to include manuscript painting and calligraphy, lacquer and metalwork, Qajar paintings, and even the ancient pottery of Iran.[3] His daughter, Maryam Massoudi, a custodian of the intellectual legacy of the collection (alas looted after 1979) and herself a collector, has continued to promote Iranian art, a passion that has infected her son Mohammed. The Tehran Museum of Contemporary Art, or TMOCA—with a collection that is no longer contemporary, for it largely predates 1979—leaves the task of representing the art of our time to private collectors such as Afkhami. Conscious of the responsibility, yet ardent in pursuing a personal vision, Afkhami has followed his instincts in forming a collection that suits the private sphere of the home but can also withstand the more critical museum context, with its exigencies of art historical importance, challenging subject matter, and quality.

In a little over a decade, Afkhami has hunted down some 300 works, many of them now iconic, spanning the modern and contemporary periods from 1961 to today. The overwhelming majority are by Iranian artists, but some 20 works are by others: Anish Kapoor, Andreas Gursky, Richard Serra (see

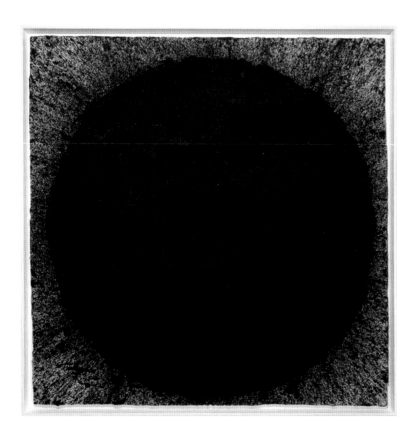

Richard Serra, *Faulkner*, 2010, paintstick on handmade paper, 200 × 200 cm
© Richard Serra / SODRAC (2016), image courtesy Gagosian

16

opposite), Robert Longo, and Yayoi Kusama, to name a few. For this
exhibition, focusing on the contemporary period only, the selection of
works by 23 artists dating from the 1990s to the present has been made
not only with the parameters of quality and space in mind but, more
importantly, with a consideration of the potential of the works to exemplify
the main discursive ingredients of Iranian contemporary art—gender, politics,
religion, and spirituality—and the dialogue they can stimulate across pluralist
positions, diverse aesthetics, and a multiplicity of mediums.

The context of the Aga Khan Museum—with its high-calibre collection of art
from Islamic civilizations and the conviction of its founders in pluralism—
provides an opportunity for viewers to ask questions and come to their
own conclusions regarding the relation of contemporary art from Iran with
ideologies and aesthetic traditions of the past; to ask if, in this new art,
these ideologies and traditions persist or are revised, contradicted, toppled,
or rather expediently espoused as the home for subversive messages. The
context encourages viewers to consider whether religion is an integral
part of aesthetic production, not just in contemporary art but also in the
historical permanent collection.[4] Shouldn't one question, as some of us
have, the very designation "Islamic" for art?[5]

Our story unfolds under four presidencies in Iran, each with its particular vision
(Akbar Hashemi Rafsanjani, 1989–1997; the reformist Mohammad
Khatami, 1997–2005; Mahmoud Ahmadinejad, 2005–2013; and Hassan
Rouhani, 2013 to the present), and three in the US (Bill Clinton, 1993–
2001; George W. Bush, 2001–2009; and Barack Obama, 2009–2016).
In the aftermath of the 1980–1988 Iran-Iraq War and the tragic events
of 9/11 in New York, Iranian artists have persevered in native ideological
climates not always in favour of free speech and a cold war with a
superpower that banished an entire nation to the "axis of evil". The works in
the exhibition demonstrate that hostile politics, wherever they originate,
are powerless in curbing cultural interconnection and self-expression.
Exchanges with the world outside continue. In our globalized epoch, some
of the exhibited artists live in the West, but those living in Tehran, such
as the video artists in the exhibition, continue to converse in a language
impermeable to both sanctions and isolationism.

Contemporary Iranian art captured the attention of people in North America in
the 1990s, at a time when the media was sensationalizing the repression
of women in Islamic countries, perhaps to justify the superiority of liberal
democracies in the West. The veiled figures that Shirin Neshat (b. 1957)
was then presenting to the art world—starting with her 1993 *Women of
Allah* series and subsequently a video trilogy (*Turbulent*, 1998; *Rapture*,
1999; and *Fervor*, 2000)—were not the first attempts to open the gender
discourse to women from the Islamic world (the efforts of Nahid Hagigat
in the 1970s and Sonia Balassanian in the 1980s preceded Neshat), but

they were initially misread and distorted, and they sometimes failed to convince viewers that within some of her images lay an indomitable will to rebel.

An allusion to rebellion concludes Neshat's narrative in *Rapture*, a black-and-white video projection on two screens. At the end, in a kind of subversive Persian reversal of the *Odyssey* (perhaps)—in which the epic hero is absent and Penelope, his wife, is left behind waiting—Neshat's veiled women move towards a sailboat and audaciously sail away towards the unknown. The men stay behind, trapped in conventions.

Neshat, a diasporic artist living in New York, shot the film on location at a beach in Morocco. *Rapture* gave birth to a highly poetic image, not as imposing as the overblown, strident photographs one is accustomed to seeing these days, but a quiet statement all the more grand for the message it leaves unsaid (see pp 124–125). The actual sailing away is not recorded, but the collective will to depart is. Resembling a flock of black birds, the women are choreographed in the photograph to move resolutely away from the viewer towards the liberating promise of freedom the sea might hold.

Poetry permeates another beach scene: the wistful video *Sundown*, 2008, by Hamed Sahihi (b. 1980), in which the sea is present only in the sound of waves crashing on the shore (see pp 130–135). The sequence was shot at the Caspian Sea in northern Iran. In the grisaille of a hazy dusk, where humans show up as silhouettes drained of colour, the unmoving camera records children flying a kite and adults strolling, carefree. These are vacationers going about life in the most uneventful manner. Lulled as they are by the ordinariness of the activities, a surreal event—the ascension of a youth into the sky—goes unnoticed, it seems. The movement is accompanied by uplifting music that at one point replaces the sound of the sea; the camera follows the young man as the sole witness. The troubling event might have remained imperceptible to us, just as it is to the vacationers, were it not for the camera—perhaps a surrogate for the artist but certainly standing in for the viewers—which follows the passage of the young man towards the heavens. His posture indicates that his death might have resulted from hanging; it is not unlike what you might see in images of a public hanging encountered on the news. Unlike Neshat, Sahihi focuses not on gender but, perhaps, on a complacent society turned insensitive to violent punishment, to suicide, or to death in general, which in this video seems as commonplace as the flying kite.

Sahihi, who lives in Tehran, has attended several workshops with Abbas Kiarostami (1940–2016), the illustrious filmmaker whose own passing, as I am writing these lines, is a recent and insurmountable loss. The two shared a taste for understatement and eloquent simplicity. Sahihi's subdued

minimalism and predilection for subtle allusion make him a poet and quiet rebel not unlike Kiarostami, who was a master of profound thoughts expressed in few words.

Kiarostami's work in the exhibition, a photographic print on canvas, belongs to a series of snow-covered landscapes he titled *Snow White* (*sefid barfi* in Persian), a series begun just as the Revolution exploded in Iran in 1978 and concluded by his death (see pp 116–117). He lived and worked in a country saturated by a cacophony of revolutionary slogans and the clamour of war. Instead of indulging in overt rhetoric, he offered landscapes uncontaminated by politics. He chose to immerse himself, and us, in the whiteness of snow as a purifying antidote. Unconcerned with the conceptual aesthetics and questions that govern photography in the West, Kiarostami followed the logic that made the most sense locally.

Did he capture the entire image in one shot or perhaps build the composition from several pictures, including separate images of tree shadows stretching horizontally across the side panels?[6] The question applies to his filmmaking too. Was he an author of fiction or a raconteur of truth without any manipulation? In his work he explored and exposed this ambiguity.

The few twigs or skeletal trees neither align horizontally, as they sometimes do in Kiarostami's processions, nor recede into space as perspective would require. By lining them up vertically on the central panel, Kiarostami endowed these humble arboreal notations with an importance the central panel of a triptych is entitled to. Stained with shadows, the unassuming side panels flank the central image of scrawny twigs rising as muted notes in all the glory of their ordinariness. The choice betrays a democratic gaze. Kiarostami respected the common.

Authors mention Kiarostami's poetic vision, the haikus he wrote, and the contemplative Zen-like spirituality that emanates from his work.[7] The Oscar-winning director and screenwriter Asghar Farhadi's words for Kiarostami's obituary were, "He wasn't just a filmmaker, he was a modern mystic, both in his cinema and his private life."[8] In 2005, Kiarostami introduced his own photographs at the Victoria and Albert Museum in London, with these words:

Snow descends
from the black clouds
with the whiteness of snow[9]

The denial of binaries has deep roots in mystical thought. The idea that luminosity is born in the heart of darkness pervades Sufism. The poem

also provides an entry into Kiarostami's coping mechanism: his ability to transcend. Armed with wisdom, he proceeded at his own pace to glorify the polar opposite of sanctioned values: the majestic silence of nature and beauty, wherever it may be, in the flesh or the spirit; joy instead of grief. Above all, refusing the perverse cult of death and martyrdom, he paid tribute to life. He was a poet and a mystic, but also a gentle rebel.

The tone changes to cheeky with Monir Farmanfarmaian (b. 1924), the doyenne of Iranian artists, whose extensive career spans the modern and the contemporary periods, but whose global recognition arrived only within the current decade.[10] She is best known for her geometric mirror works inspired by the architectural surface decoration of shrines and palaces in Iran. She engaged with this medium and combined it with reverse glass painting first in the late 1960s but with most success beginning in the 1970s. In the United States in the 1940s and 1950s, Farmanfarmaian was a student of fashion illustration and then a freelance illustrator. With *The Lady Reappears* of 2007, she returned to her origins—her interest in the fashion world (see pp 90–91). Flipping through a magazine, her attention was caught by the drapery of a dress clinging to a model's body.[11] She cut off the figure's head and, defying tradition, translated the female body into a medium incompatible with figuration. Her personality has a tinge of mischief, and this seeps into the work. Leaving the head out, off goes the mandatory veil.

Gender has many facets. Parastou Forouhar (b. 1962) approaches the female body by leaving it out, the way some fundamentalists would prefer. In *Friday*, 2003, (the title referring to a day of rest and prayer), a black curtain reminiscent of a chador fills all four photographic panels with only a fist exposed, clasping the edge of the fabric (see pp 92-93). Obliterating the body, however, does not succeed in erasing eroticism; the realm of imagination overworks to compensate for censorship. The more you forbid, hide, and favour opacity, the work seems to imply, the more you extend the erogenous zone. Thus the fetishized hand that peeks out of the veil acts as a surrogate for the core of the forbidden. Forouhar lives in Germany but does not miss visiting Iran, where her activist parents were assassinated in 1998.

The absence of the body is unusual in an oeuvre in which they are often depicted bending and contorting, as in a macabre dance between innocents and torturers. If bodies are absent, knives and other ominous objects may be endlessly multiplied into decorative patterns like wallpapers that frame the viewer's vision, echoing a trauma without finality. In other works, the artist's *Written Rooms*, 1999–ongoing, black calligraphy slashes the white environment in a script whose letters cut like swords, sweeping gestures linking floor and ceiling (see opposite). They are letters severed from words, bereft of sense. Like musical notation, they visualize sounds; they

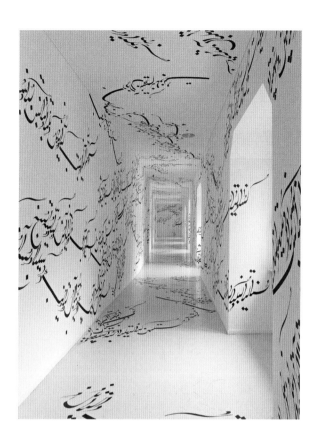

resound in the empty space like cries, screams, or restless prayers. Unlike
drip painting, each movement is meticulously laid down. Controlled,
stylized anger appears to be Forouhar's weapon of choice. The artist's own
interpretation differs from this drastically, however, in that, for her, the
rhythmic dance of these calligraphic notations conveys the melody of her
native tongue, an abstract testimony to her roots.[12]

In her *Qajar* series (1998–2001), two works from which are in this exhibition,
Shadi Ghadirian (b. 1974), who lives in Tehran, treats the issue of gender
through photographs purporting to be of Qajar women posing in
photography studios—sites where identities are constructed (see pp 95 and
97). Created as a thesis project, the selected images were taken in the studio
of Bahman Jalali (1944–2010)—a revered photographer and, at the time,
Ghadirian's thesis adviser—against an original backdrop from the "Akkas-
khaneh Chehreh Negar", a photography studio in business from the late
Qajar period until early in the Pahlavi regime.[13] The backdrop emulates a
European setting and Ghadirian's models are family and friends. They are
dressed in original Qajar attire that the artist borrowed from the archives of
the national television station ranging from a strict, traditional veil covering
the entire body (face included) to a version of the "modernized" costume
the Qajar court adapted from the West: the short skirt, or shaliteh, that

21

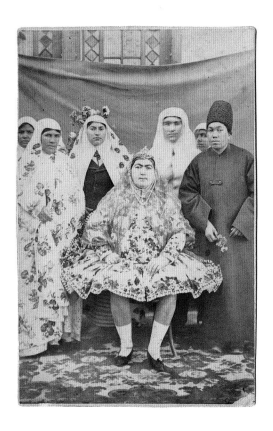

Anis al-Dawla, Naser al-Din Shah's wife and her retinue,
c. 1870–1880, photographic print 21 × 13.8 cm. Photo attributed
to Naser al-Din Shah Qajar or Reza Akkasbashi Albumen
Courtesy of the Kimia Foundation

common lore ascribes to Naser al-Din Shah's ludicrous fascination with the tutu, which he had seen worn in ballet performances during one of his trips abroad (Saint-Petersburg or Paris?) and subsequently imported to his harem.[14] Having introduced photography to Iran soon after its invention, Naser al-Din Shah took pictures of members of his harem wearing the garment (see above).[15] During the Pahlavi regime, in the 1960s critics came to call this type of absurd emulation of things Western "Westoxication".[16]

Ghadirian does not defy the current codes for representing women in Iran, but one of her models does ride a bicycle. She explains, "My love of photography and my interest in Iran's social history started when my photography teacher, Bahman Jalali, showed us nineteenth-century Qajar portraits. I was intrigued by the women in these photographs, women holding bicycles—something we are forbidden to do—wearing strange make-up and costumes inspired by European dancers."[17] Ghadirian includes anachronistic objects, such as a boom box, a can of Coke, a security helmet, and other signs of the post-Qajar era in her scenes, underlining the lure and influx of Western models and commodities. With ramifications beyond the Qajar era, the images implicate anachronism itself as a continued mentality.

Iranian contemporary artists frequently appropriate the past, especially the Qajar era, as a strategy for critiquing and commenting on the present. Ghadirian's critique benefits from the comic tenor she brings to her scenarios, staging, for instance, two women whose identity is fully concealed but who nonetheless are posing for their portraits. The satirical gaze extends to the studio prop, the easel painting on the left which, in the artist's words, is an "action painting" (one more anachronism) lent to her by an art student, a work in the manner of Jackson Pollock.[18] The punch line of the joke is in the "action painting"; a woman dressed like those pictured in the photograph would be deprived of the freedom, gestural or otherwise, needed for action.[19]

Humour eases the constraints of a life lived under pressure. Shirin Aliabadi uses a high dose of it in her *Miss Hybrid* series, in which she records the histrionics of the escape, the masquerade of defiance (see pp 59–61). In her studio she stages models based on contemporary women in today's Iran, whom the artist, who lives in Tehran, knows well. These women, of a type sporadically encountered in Iranian urban life, are those rebels engaged in what Azadeh Moaveni has called "the lipstick jihad".[20] These women are the children of the Islamic Revolution, but they do not relate to a revolution they did not generate. Their childhood was spent under the deprivations imposed by the war with Iraq, but they experienced a hint of relative freedom during the reformist era of the Khatami presidency (1997–2005), when they dared to redefine their dress code and experience the relative openness that accompanied the arrival of the Internet. With their hair dyed peroxide blonde, a nose job apparent from a plastic strip, and blue contact lenses, their carnivalesque overreaction to the sanctioned codes of public appearance go as far as denying the existence of an Islamic or even an ethnic or national identity. In the hands of today's rebellious youth, the Westoxication latterly interpreted as a critique of the Pahlavi regime has become a weapon to be used against the current authorities. With this series, Aliabadi claims, "cultural rebellion meets Christina Aguilera".[21]

In this exhibition, and perhaps in Iranian contemporary art in general, Rokni Haerizadeh (b. 1978) may be deemed the ultimate jester. With his brother, Ramin Haerizadeh, and their childhood friend Hesam Rahmanian (all three now living in Dubai), he creates messy, farcical Gesamtkunstwerk that they have exhibited around the world, from Dubai to New York and Boston, to Hong Kong to the 2016 Liverpool Biennial. *We Will Join Hands in Love and Rebuild our Country*, 2012, by Rokni Haerizadeh, provides an entry into a concocted comedy and damning critique of the politics he has left behind (see pp 98–99 and 101). The title comes from Abbas Yamini Sharif (1919–1989), who wrote songs and poetry for children. Rokni remembers reciting them in elementary school.[22] The naïve "kumbaya" tone of the title announces a nation-building attempt, metaphorically represented in the painting by a population crammed into the body of

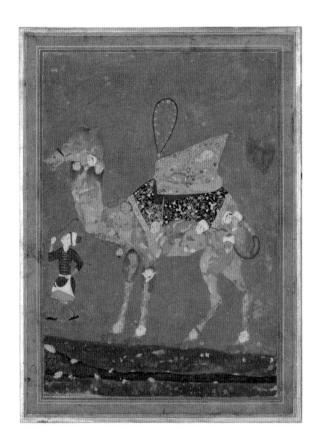

Composite painting of a camel with attendant, Iran,
Khurasan, third quarter of the sixteenth century
ink, opaque watercolour and gold on paper, 12.7 × 18.4 cm
Gift of George D. Pratt, The Metropolitan Museum of Art, 1925

what could be any number of animals—maybe a cow, perhaps a donkey—
ridden by Molla Nasreddin, a character famous in Iran and beyond, riding
his donkey backwards. Leading from behind, he looks to the past rather
than the future.

The composite animal was inspired by a genre of paintings that includes, for
example, the sixteenth-century depiction of a camel with attendant from
Khurasan, Iran, in the collection of The Metropolitan Museum of Art (see
above).[23] By depicting the animal standing on a red balloon—a spectacle
watched and photographed by a Western journalist on the left—Haerizadeh
turns the collective nation-building enterprise into a risible affair, worthy of
a circus.[24]

Armed with humour, Khosrow Hassanzadeh (b. 1963) targets America. His
Terrorist: Khosrow, 2004, a large silkscreen, is one of seven unique prints,
each in a different colour (see p 103). A later mixed media variation
(*Khosrow* from the *Ready to Order* series), is framed in a shadow box (see
opposite). It features a display of fake flowers and light decoration that
is even more in tune with the local vernacular: the kitsch paraphernalia

Khosrow Hassanzadeh, *Khosrow* (*Ready to Order* series),
2007–2008, mixed media, 199 × 135 × 35 cm
Collection of the artist

encountered in memorial shrines placed over the tombs of martyrs who
died in the war. In *Terrorist: Khosrow,* Hassanzadeh stages his self-portrait
against the kind of backdrop used in old photography studios, including
a picture of a waterfall based on a poster he bought in Lalehzar, a street
in an old Tehran neighbourhood. Seated on a kilim, he holds a picture of
his grandfather in his left hand and a pot of flowers in his right, placed on
a large box made in Yazd. Boxes hold secrets, he says.[25] This dominating
pater familias, appropriating for himself the grandiosity of the larger-than-
life revolutionary icons whose images are plastered on city walls and
billboards, is flanked by diminutive images of his son leisurely lounging
on the grass at top right and his demure daughter at top left—in short,
he depicts a regular, peaceful, proletarian family portrait rendered in a
palette that is innocently pink and baby blue. To each portrait he affixes
an identity certificate, which in the case of the self-portrait indicates his
name, nationality, religion (Muslim), age, profession, distinctive traits,
and, most notably, in quotation marks and capital words the word
"TERRORIST" (see p 102). Hassanzadeh's fascination with popular culture
has led him to Andy Warhol, who he has admired since 1999 and whose
portrait has recently entered into his cast of characters. The impact the

Pop artist left on Hassanzadeh is visible throughout his oeuvre, especially in his serial portraits, each treated in a different colour, and the choice of silkscreen as medium. Effortlessly, Hassanzadeh translates the American language of Pop into Iran's kitsch, religious, and revolutionary culture and comes up with a vernacular that is Persian in its references but Warholian in its accent. As a *basiji*—a volunteer in the Iran-Iraq War, a conflict widely believed to be a US imposition— an early supporter of the Revolution, and as a Muslim and an Iranian, in the *Terrorist* series he seems to be asking American authorities, "Am I, is my family, are my kids, my veiled mother, my dead grandfather terrorists?"[26] Warhol's attention to commercial products is rerouted here into the branding of human lives, exploited purely for the economy of war and politics. Hassanzadeh's focus never veers away from the plight of humans.

The date is important. George W. Bush, who labelled Iran as part of the "axis of evil", and by extension deemed all Iranians as terrorists, was the President of the United States when the series was created in 2004. Harassment at airports, where suspicion of terrorism hovers around Middle Eastern men, has further fuelled Hassanzadeh's defiance. In applying the epithet "terrorist" to his quaint family portrait he astutely questions Bush's demonization and highlights America's failure to understand the culture and humanity of others.

Whereas humour is not an ingredient readily associated with contemporary Iranian art—although, as demonstrated here, it is a form of ammunition many artists take advantage of—critique and dissidence, recognized as this art's trademarks, nestle in unsuspected nooks and crannies; the target, however, is not necessarily the regime in Iran but a range of authorities. This critique is camouflaged; elusive and allusive, it is levelled in highly nuanced ways. We see it among artists living both inside and outside the country. In this text we have already discussed various shades of defiance; we continue with the diasporic Afruz Amighi (b. 1974), living in New York, and Nazgol Ansarinia (b. 1979), who lives in Tehran.

Amighi's medium, in a sense, is light and shadows, a duality close to the Zoroastrian thinking of her ancestors. She projects light onto hanging screens (made of material used for tents in refugee camps) so that the patterns she has carved are imprinted as shadows on the back wall. Like a hanging carpet, the work emulates floral ornamentation, but it also recalls painted pages inhabited by angelic creatures.[27] In Amighi's *Angels in Combat I*, 2010, trespassing the borders the guardian angels turn into executioners, pointing their machine guns at the tree of life, the most prominent motif at the centre of the screen (see pp 63-65). Amighi based this motif on Turkish tiles. [28] Commingled within the ghostly all-over ornamentation is the "caduceus, a staff entwined with two serpents, sprouting wings. In Roman iconography it was often depicted in the left

hand of Mercury, protector of merchants, thieves, gamblers, and liars. Interestingly, in North America this symbol is used as a medical symbol. It can be seen on everything from pharmacies, ambulances, hospitals", says the artist.[29] Amighi appears to be indicting a medical system in an advanced country such as the US (or anywhere) where life can be threatened and not protected. She conceals her critique in a language of poetic metaphor and convoluted ornamentation.

The carpet designs of *Untitled II* (*Pattern* series), of 2008 by Ansarinia—digitally printed ink drawings—seem at first glance to weave arabesques of vegetation; closer inspection reveals vignettes with human protagonists: drummers during ceremonies in the holy month of Moharram, traditional athletes from the Zoorkhaneh ("house of strength", or traditional gym), cyclists, anchormen and -women on TV, housewives queueing for food, office clerks drinking tea, and objects such as the ubiquitous satellite dishes, which are sometimes allowed by the regime, at other times confiscated (see pp 71–75). The toppled authority in this work is an artistic tradition with age-old patterns and conventions, violated by the intrusion of mundane realities.

Ansarinia, like Amighi, has moved on to architecture as a vessel for her message. *Pillars: Article 47*, 2015, takes its cue from the opulent copies of ancient and Renaissance architecture that have cropped up in recent years in the newly rich neighbourhoods of Tehran (see pp 67–69). Cut open like a piece of cake, the exposed text reads, "Private ownership, legitimately acquired, is to be respected. The relevant criteria are determined by law"—a line from Article 47 of the Iranian Constitution. The message is a pungent allusion to the dubious finances behind the boom of ostentatious buildings.

Architecture, war machinery, and the concept of power inform works by two other artists: Timo Nasseri (b. 1972), son of a German mother and Iranian father, who lives in Berlin, and Shahpour Pouyan (b. 1977), who lives mostly in New York. The second Gulf War ignited Nasseri's interest in military devices—slick on the outside but deadly in purpose. The names given to military hardware by Americans (such as Apache) or by Iranians (*Shahab*, meaning "falling star"), echo a poetic beauty masking deadly violence that he has translated into his sculpture. Nasseri combines this interest with an attention to Islamic architecture, specifically the honeycomb vaults known as muqarnas, which tower over a viewer's field of vision. One result is his *Parsec* series, 2008–2010, including *Parsec #15*, 2009 (see pp 121–123). A parsec is a unit of distance used in astronomy. Its application to what appears to be an otherworldly, star-like object that has landed on our planet evokes not just the cosmic distance it may have travelled and the Islamic architecture it has cannibalized on its way; it also hints at a brilliant, stylized explosion right here on Earth. Its beauty is nothing if not subversive.

Pouyan's *Unthinkable Thought,* 2014, consists of nine ceramic domes, seven of
 which are in the Afkhami collection (see pp 128–129). Each is modelled on
 a structure plucked from a different civilization and era, from the Pantheon
 in Rome to tomb towers and mosques in the East. One dome, Germania,
 was modelled after an unrealized project planned for Hitler by Albert Speer;
 the largest dome, imaginary, looming as a nightmare, gigantic in ambition
 and frightening in its blackness, is titled Iranistan.[30] The tainted history of one
 and the unwholesome appearance of the other seem to suggest a critical
 intention. Hubris informs these "fake skies" that memorialize power and
 immortality and denote a fundamental "glitch" (in the artist's words) in the
 human DNA.[31] Failed ambitions may not result in historical lessons learned.
 Grander and darker aspirations loom in the future.

The universality of the aggressive instincts manifested in war is clearly enunciated
 in the suspended *Projectile 11* (see p 127). Phallic in appearance, it conflates
 Medieval armour—crowned with a helmet inscribed with Ferdowsi's poetry
 from the *Shahnameh* (*Book of Kings*), an epic replete with accounts of
 mythological battles—and today's American drones. The spectre of war
 hovers as a menacing bird.

The arts of ceramic- and armour-making are highly specialized. Pouyan learned
 them by working with two Chinese ceramics masters in California (the
 brothers Guangzhen Zhou and David Zhou) and professional metalsmiths
 in south Tehran. He learned the chain-mail technique from Ostad
 Ensaf Manesh.[32]

Seductive but deadly, Pouyan's missile and Nasseri's fallen object keep company
 with the generic military aircraft by Farhad Moshiri (b. 1963) that has
 pierced his *Flying Carpet* (see pp 118–119). The artist was inspired by
 a documentary he saw on Afghan carpet weavers who incorporate into
 their designs the fighter planes and drones they see flying above them
 (see opposite).[33] Moshiri reimagines one such lethal monster imprinting
 a deep, dark shadow within 32 stacked, machine-made Persian carpets.
 Carved out from their very heart is a fighter aircraft, which, having violated
 the domestic space (carpet bombing is the wrong expression, but it comes
 to mind) of an Islamic culture, lies intact to the side. Here Moshiri may be
 referring not just to the ongoing US military interventions in the region
 but also to the palpable threat of war that has unsettled Iranians over the
 controversial nuclear issue. With this work, Moshiri delivers the ultimate
 critical dart regarding foreign intervention in the magical land of Orientalist
 fables, but the tone stays whimsical and light just like the fighter aircraft
 which has landed neatly like a paper plane. Here, these carpets infiltrate
 the Aga Khan Museum's permanent collection, allowing for a comparative
 analysis with the apolitical, superbly crafted mid-sixteenth-century Safavid
 carpet they have replaced.

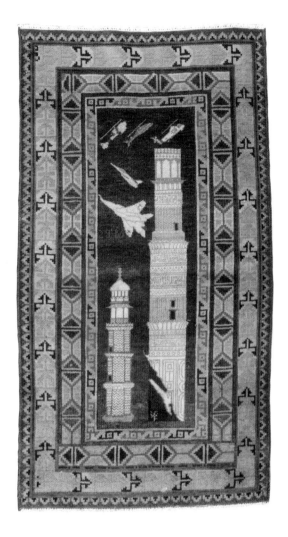

Double Minaret War Rug, Afghanistan, 2002
wool pile warps and cotton wefts, 155 × 87 cm
Collection of Kevin Sudeith, New York

War has left an indelible impact on a generation of artists who spent their
childhood in the 1980s in an Iran embroiled in battles with its neighbour
Iraq. Ali Banisadr (b. 1976) and Shiva Ahmadi (b. 1975) are two examples.
Banisadr revisits the trauma of missiles exploding and sirens screaming in
paintings that are descriptive not of an outer reality but perhaps of inner
demons or a mental turmoil the artist attempts to harness—to choreograph
as a master puppeteer from outside and above. In epic sceneries in which
chaos reigns and the integrity of form is shattered into near abstraction, the
inhabitants of this world, deformed into creatures not fully formed, come
from all cultures, all epochs. The title of *We Haven't Landed on Earth Yet*,
2012, alludes to humans' first steps on the moon but at the same time
points to the idea that technological progress has not been able to curb
humankind's destructive instincts (see pp 81–83). If there is any critique in
this painting, it is of humanity itself.

As has been often stated in the literature on the artist, Banisadr's art historical vision is encyclopedic, with a strong predilection for the grotesque exemplified by Hieronymus Bosch and the aerial views of battle scenes in Persian manuscript paintings.[34] Banisadr left Iran at age 12, at the end of the Iran-Iraq War in 1988, but Ahmadi did not move to Michigan until 1998. It was not until the US invasion of Iraq in 2003 that she allowed her own memories of the war to pour into her art in an exotic language she deliberately adopted to maintain her political distance from Bush's war and assert her cultural difference.[35] She extends that language to fetishized oil barrels covered in lavish ornamentation, yet she defaces that exoticism with a bleeding bullet hole, thus alluding to the connection between the logic of war and the lust for oil (see pp 53-55).

The oil barrels by Mahmoud Bakhshi (b. 1977), if they can be read as such, have no relation to exoticism or any kind of opulence. Rather they have an affinity with a culture of austerity, of the dispossessed and the deprivation hailed by the Revolution—if not today then at least at its inception. Bakhshi appropriates the visual culture and imagery of the Islamic Republic and navigates within it into an ambivalent zone oscillating between propaganda and critique. Conflating the iconography of the Islamic Republic with rudimentary technology and transcendental aspirations with kitsch and humble materials is a common practice in Bakhshi's art. His 2008 *Tulips Rise from the Blood of the Nation's Youth*, from his *Industrial Revolution* series, is a case in point (see pp 77–79). In this work Bakhshi has attached logos of the Islamic Republic—the stylized calligraphy reading Allah that also doubles as a tulip, a metaphor for the martyrs of the revolution—to pedestals of tin, a material with dual associations: both oil barrels and the building material used in the shanty towns of Iran's dispossessed. This marriage between high ideals and empirical realities reiterates the stated affiliations of the Islamic Revolution with the dispossessed while opening the door for other interpretations. Bakhshi's logos are made of neon. Repeated and electrically revolving, these emblems offer a spectacle reminiscent of electric signs in modern advertising. The message, however, is not commercial. Shining with a sinister glow, the tulips that rise from the blood of a nation's youth advocate martyrdom for the benefit of faith and revolution.[36]

Religion and spirituality occupy several artists in this exhibition. Bakhshi points to the rhetoric and signage of state-organized religion; Alireza Dayani (b. 1982) looks into alternative stories regarding the origin of life. In presenting a spectacular aquarium (he owns one, himself), a panoramic vista of the ocean, in an ongoing series he has titled *Metamorphosis*, he presents a fictionalized narrative of creation (see pp 84–87).[37] Aquatic life, its fauna and flora both imagined and scientifically precise, is obsessively described. The overwhelming profusion of details and the myriad of creatures depicted from all angles almost overwhelms the tentative

allusions to human life: some semi-human and erect figures and one not-yet-fully-formed, mermaid-like, possibly female creature. Had human life emerged in the depths of oceans it might have looked as it is imagined in this visionary work.

Dayani is the youngest artist represented in the exhibition. Mohammad Ehsai (b. 1939), who comes from the generation of modernists who flourished in the 1960s and 1970s, offers a different perspective on the universe, spelled out in traditional aesthetics. Ehsai lives between Tehran and Vancouver. A master of calligraphy, he is also a practitioner of so-called calligraphic modernism. His art is deeply rooted in the spiritual thinking of Rumi. With Ehsai, we move away from the visible world into the realm of symbolic concepts embedded in the form and meaning of words. *Mohabbat* ("kindness"), which is also the title of the work, is repeated four times, like a lightning bolt reaching into the corners of the canvas and in the four cardinal directions (see p 89). Seeming to whirl in a fiery dance, the words give up their individual legibility but they remain connected as a single entity. The glue that holds the entangled letters, the artist explains, is the magnetism of *mohabbat*, a force or sentiment with ties to love. In formal terms, Ehsai, a devout mystic, enunciates the Sufi aspiration to transcend individuality to merge into a form greater than the self.

Parviz Tanavoli (b. 1937), another artist who divides his time between Vancouver and Tehran, is a scholar and collector, but above all an eminent artist. He is considered to be the father of Iranian modern sculpture. His erect anthropomorphic sculptures are often titled "poet" and "prophet", but he has also created scripts with alphabets he has invented. The only script he has not invented is the calligraphy he has appropriated, of the *nasta'liq* genre, for the word *heech* (meaning "nothing" or "nothingness"), which, beginning in the early 1970s and continuing today, he has produced in all colours, mediums, and sizes, from sculptures larger than the tallest adult to a ring made to be worn on a finger (see p 137). Is the word an existential statement, a poetic metaphor, or, infused with the esoteric sensibility of mysticism, a conflation of opposing principles of nothing and everything into one—separating the apparent, or *zahir*, from the inner meaning, the *batin*? All of these interpretations are plausible, but given the artist's avowed aversion to calligraphy and its commodification, I have suggested the word is nothing more than a Trojan horse that Tanavoli uses to penetrate calligraphy, only to proclaim its nothingness.[38] Perhaps a poet, perhaps a mystic, he is also possibly a rebel.

Rebellion is a sentiment alien to some artists. Among them is Shirazeh Houshiary (b. 1955), who seeks a world beyond strife. Abstraction has often been a conduit of spirituality, and Houshiary is arguably its main exponent in contemporary art. Her spirituality comes across in esoteric garb, through an art of concealment. Unlike the declamatory presence

31

of *mohabbat* in Ehsai's work or *heech* in Tanavoli's, Houshiary's surfaces pullulate with words that do not fully appear. Inscribed by the artist but then erased, they advance and retreat as traces, as aura, as hints, as energy, as horizontal halos, and more. They intimate but do not divulge. They stand at the cusp of what is and what is not. Presence and absence oscillate back and forth, morph into one.

The blue band in *Memory*, 2005, pregnant with unseen words, suggests a serene ocean, a water image found in Rumi's poetry (which the artist admires)—a metaphor containing the idea of "unfathomable depth" (see pp 105–106).[39] This is the only active area of the painting; it has emerged in the centre of an expanse that can be characterized only by what it is not, by the primary matter of not being (*'adam*). No rigid boundary separates the blue band from the nothingness it may again dissolve into.[40] We may be treading deep into a mystical territory. Guided by the title, we may ask, "What is memory if not the result of an attempt to rescue something from oblivion?" The artist has compared the painting to "an opening through the mist", an "immensity", and the "infinity of the unknowing". For her, the work is evidently not tied to biographical and personal recollections but rather to a grander perspective, to a philosophical quest for the birth or process of consciousness itself.[41]

In the case of the glass sculpture Houshiary has named *Pupa* (named for the transformational stage in insects between larva and adult) she succeeds in materializing a state of flux that a solid sculpture would not be conducive to (see pp 108–111). In its twisting vortex, it swells and deflates, expands and contracts, and rises as if weightless yet collapses under its earthbound weight, all within a translucent body which allows light to affect the pale, wine-coloured tonality of its blushingly pale skin. A concrete, inanimate construction of glass bricks poses as an organic process, a cycle of continual becoming.[42]

Houshiary and Y.Z. Kami (b. 1956), are both diasporic artists—the former living in London, the latter in New York—whose aesthetic metabolisms are impregnated with mysticism. Both are erudite devotees of spirituality as issued from a diversity of belief systems outside organized religion. Their paths, however, diverge when it comes to stylistic genre: Kami's practice revolves around portraiture, on the one hand, and architectural spaces as symbolic catalysts, on the other.

Answering the question "What is Sufism?" Rumi said, "To find joy in the heart when grief comes."[43] The statement is relevant to the domes Kami has painted, photographed, digitally printed, and collaged throughout his career. In 1997 he exhibited at the Museum of Modern Art, New York, a diptych in which gyrating bricks of Iranian Medieval domes evoke sentiments as divergent as those evoked by Rumi: a billowing darkness in

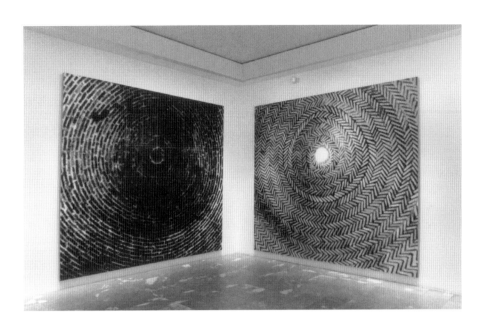

one and the uplifting promise of light in the other (see pp 113–115). In
Rumi's statement, joy and grief overlap: they share the same location, as it
were. Kami separates the two as if they were stages in a process—a method
that is not unfamiliar to the alchemical thinking Kami is well acquainted
with, especially in its Jungian application to psychology. In this sense, his
recent *Black Dome*, 2015—triggering a vertigo of fear that swallows the
viewer into its tenebrous core—conjures the "nigredo" (the blackness that
is the first stage in alchemical transformation) one must work through and
overcome before reaching the stage of white domes drenched in luminosity
that Kami represents separately (see above). No matter the intensity of light
or its absence, Kami's domes exist outside of "cartographical dimensions",
a term used by Henry Corbin, an illustrious scholar of Islamic mysticism
known to the artist.[44] Rather, they reflect a spiritual space with its own
orientation. Light and darkness are the protagonists in scenarios Kami
has obsessively staged. Repetition with constant variation is a principle he
applies to all his art, whether in his black or white domes, his turquoise or
gold domes, or in the humanity that he brings to life in his portraits and yet
keeps suspended at the edge of departure. Just as in Houshiary's works, flux
permeates all manifestations.

Historically, Sufism, as a vein of spirituality, has been tainted with rebellion.
It has thrived but almost always as a practice distinct from organized
religion, and at times during its turbulent history "a number of Sufis or
mystically inclined thinkers—like al-Hallaj and Sohravardi, for example—
were condemned as heretics by the ulema".[45] Whatever its significance

may be for the "mystics" in the exhibition, the principles they uphold (in works seen here and otherwise) they defy divisive ideologies and reach for a common humanity. In this respect Morteza Ahmadvand (b. 1981) delivers a message of utmost importance for the divisive times we are living in. In his video installation *Becoming*, 2015, he addresses a plea to the three religions of the Abrahamic tradition: Judaism, Christianity, and Islam (see pp 56–57). He has taken an emblem of each (the Star of David, the cross, and the kaaba) and subjected them to an almost imperceptible formal process; they morph into a perfect sphere, not merely projected on each screen but also materialized in the centre of the space, perhaps as a reminder of the single planet we all inhabit.

In spite of the sanctions, isolation, political unrest, and exile characterizing Iran in this new millennium and the lack of solid commitment on the part of major institutions outside the country (with the exception of very few), the creative forces of Iranian artists have not been dampened. This should not be attributed to the commercial success that many have found. For the narratives presented here are woven out of genuine obsession and a refusal to surrender in silence. In their defiance, momentous or light-hearted, and in their transcendental visions they reveal that they are the victors over circumstance and not its victims. Their stories have been told before. This is not the first exhibition on the subject, but it is the first to cast these artists and their works in the light of their fortitude, their strategies, and their coping mechanisms. The intention has not been to use their art to provide illustrations for political realities but rather to note the polyphony, to look at each artist, each work, analyze its content, and see what it has to say and how each says it differently.

Notes

1. As noted by Ervand Abrahamian, "A government circular explained that whereas 'Persia' was associated with Fars and Qajar decadence, 'Iran' invoked the glories and birthplace of the ancient Aryans." See Abrahamian, *A History of Modern Iran*, Cambridge, UK, and New York: Cambridge University Press, 2008, p 86 and footnote 50. For further reading, see Axworthy, Michael, *A History of Iran: Empire of the Mind*, New York: Basic Books, 2008; Keddie, Nikki R., *Modern Iran: Roots and Results of Revolution*, updated ed, New Haven and London: Yale University Press, 2006.

2. Venetia Porter, who looked at the collection before I did, suggested the title "Contemporary Persians", which I adopted as a subtitle especially because of the identity dissimulation it has allowed.

3. Email from Maryam Massoudi to the author, 2 July 2016. See also Aghdashloo, Aydin, *A Selection from the Collection of Mohammad-Ali Massoudi: Specimens of Iranian Calligraphy since the 9ᵗʰ Century A.D.*, Tehran: Reza Abbasi Museum, 1978; Robinson, B.W., "An Illustrated Masnavi-I Ma'navi", *Iran and Iranian Studies: Essays in Honor of Iraj Afshar*, Kambiz Eslami ed, Princeton: Zagros Press, 1998.

4. See *Pattern and Light: Aga Khan Museum*, texts by Henry S. Kim, Philip Jodidio, D. Fairchild Ruggles, Assadullah Souren Melikian-Chirvani, and Ruba Kana'an, New York: Skira Rizzoli, 2014.

5. Melikian-Chirvani has adamantly opposed the use of "Islamic" for art. See, for example, Melikian, "When Cultural Identity Is Denied", *The New York Times*, 9 March 2012. See also Daftari, Fereshteh, "Introducing Art from the Middle East and its Diaspora into Western Institutions: Benefits and Dilemmas", *Contemporary Art from the Middle East: Regional Interactions with Global Art Discourses*, Hamid Keshmirshekan ed, London and New York: I.B. Tauris, 2015, pp 187–202.

6. How this image was constructed is a question that shall very likely remain unanswered, for my query reached the artist when he was too ill to speak about his work.

7. See Kiarostami, Abbas, *Walking with the Wind: Poems*, Ahmad Karimi-Hakkak and Michael Beard trans, Cambridge, MA: Harvard Film Archive: Distributed by Harvard University Press, 2001.

8. Quoted in Pulver, Andrew and Saeed Kamali Dehghan, "Abbas Kiarostami, Palme d'Or-winning Iranian filmmaker, dies aged 76", the *Guardian* (online), 4 July 2016.

9. *Abbas Kiarostami: Visions of the Artist*, London: Iran Heritage, 2005, p 7.

10. The three exhibitions Rose Issa organized for her in London starting in 2001 paved the way. More recently her inclusion in the exhibition *Iran Modern* (Asia Society, New York, 2013) and an extensive representation at the Guggenheim, New York, in 2015, have established her as a dominant figure in Iranian modern and contemporary art.

11. Personal communication to the author, winter 2016.

12. In an email dated 27 July 2016, she wrote: "Being in such a space is like experiencing the music and the melody of the language. It has a notion of liberating dance and lightness."

13. I would like to thank Rana Javadi (photographer and married to the late Bahman Jalali) and Shadi Ghadirian for the information communicated to me in July 2016.

14. These garments are used by actors who play in serials produced by the national television station.

15. For some images of the court women photographed by Naser al-Din Shah, see the *Eye of the Shah: Court Photography and the Persian Past,* Jennifer Y. Chi ed, New York: Institute for the Study of the Ancient World at New York University, 2015, nos 68, 72–73, 92.

16. The term was invented by the philosopher Ahmad Fardid and popularized by Jalal Al-e Ahmad in the 1960s. See Al-e Ahmad, Jalal, *Occidentosis: A Plague from the West,* Persian Series, Berkeley: Contemporary Islamic Thought, 1983. For the influence Fardid and Al-e Ahmad exerted on the Revolution, see Secor, Laura, *Children of Paradise: The Struggle for the Soul of Iran,* New York: Riverhead Books, 2016.

17. Ghadirian quoted in Issa, Rose ed, *Iranian Photography Now,* Ostfildern, Germany: Hatje Cantz, 2008, p 48.

18. Communication to the author, July 2016.

19. Ghazel is another artist who has pursued the absurd logic of constraints placed on women's activities. Her ongoing *Me* series of videos that she started in 1997 (not in this collection) represent activities impossible to pursue wearing a chador, such as sunbathing and ballet dancing.

20. Moaveni, Azadeh, *Lipstick Jihad: A Memoir of Growing Up Iranian in America and American in Iran,* New York: Public Affairs, 2005.

21. Shirin Aliabadi, quoted in Cook, Xerxes, "Blonde Faith", *Tank,* 2010, p 74, gotank.posiweb.net.

22. Communication to the author by email, 30 March 2016.

23. I would like to thank the artist for the image and Maryam Ekhtiar for identifying it in the collection of The Metropolitan Museum of Art.

24. The identification is the artist's. Communication to the author, March 2016.

25. Communication to the author, Tehran, March 2016.

26. See Hassanzadeh, Khosrow, "How Did I Become a Painter?", *Tehran Studio Works: The Art of Khosrow Hassanzadeh,* Mirjam Shatanawi ed, London: Saqi Books, 2007. This publication provides a concise introduction to the themes found in Hassanzadeh's work.

27. As explained by Assadullah Souren Melikian–Chirvani, "Persian miniatures" is "a misleading expression implying that they are independent works standing on their own". Instead, he proposes "painted pages". See his essay, "Prince Sadruddin Aga Khan: A Collector in an Age of Connoisseurship", *Pattern and Light: Aga Khan Museum,* Toronto: Aga Khan Museum, p 41.

28. Communication to the author by email, 11 July 2016.

29. Communication to the author by email, 24 March 2016.

30. The term was used to arouse fear when, in the 1970s, the Shah said that Iran, under his watch, would never become "Iranistan", i.e., a Soviet province.

31. The words in quotation marks are the artist's. Email to the author, 13 July 2016.

32. Communication to the author by email, 1 January 2016.

33. Email to the author, 28 July 2016.

34. See Daftari, Fereshteh, "Voices of Evil: A Common World Order", *Ali Banisadr,* Paris: Galerie Thaddaeus Ropac, 2010 and *Ali Banisadr: One Hundred and Twenty Five Paintings,* London: Blain Southern, 2015, which includes a text by Robert Hobbs and conversation with Boris Groys.

35. On the question of exoticism or post-Orientalism, see Daftari, Fereshteh, "Shiva Ahmadi: Altered Miniatures", *Canvas*, vol 7, no 2, March–April 2011, p 185.

36. This section is based on the essay I wrote for the artist's exhibition at the Saatchi Gallery in London on the occasion of his winning the 2009 Magic of Persia contest. See Daftari, "City of Tales, Updated", *Mahmoud Bakhshi. The Engaged Artist*, London: Saatchi Gallery, 2010. For further discussion of the work see the Vali Mahlouji's interview with the artist in *Raad O Bargh: 16 Artists from Iran*, Paris: Galerie Thaddaeus Ropac, 2009, pp 24–25.

37. Communication to the author, 7 April 2016.

38. See Daftari, Fereshteh, "Redefining Modernism: Pluralist Art Before the 1979 Revolution", *Iran Modern,* Daftari and Layla S. Diba eds, New Haven and London: Asia Museum Society and Yale University Press, 2013, p 34. On Tanavoli and "*Heech*", see also Tanavoli, Parviz ed, *Heech: Parviz Tanavoli*, Tehran: Bongah, 2011 and Akbarnia, Ladan with Francesco Leoni, *Light of the Sufis: The Mystical Arts of Islam*, Houston: The Museum of Fine Arts, distributed by Yale University Press, New Haven and London, 2010, p 64.

39. For further elaboration on the imagery and the mystical meaning of "unfathomable depth", of not being in its positive aspect, see Schimmel, Annemarie, *Rumi's World: The Life and Work of the Great Sufi Poet*, Boston and London: Shambhala, 2001, p 81.

40. On the concept of '*adam*, see Schimmel, *Rumi's World*, pp 79–81.

41. Communication to the author by email, 31 December 2015.

42. For a thorough analysis of Houshiary's recent sculptures, see Golding, Francis, "Everything Flows: New Sculptures by Shirazeh Houshiary", *Smell of First Snow: Shirazeh Houshiary*, London: Lisson Gallery, 2015, pp 43–46.

43. Mathnawi, quoted in Annemarie Schimmel, *Mystical dimensions of Islam*, Chapel Hill: The University of North Carolina Press, 1975, p 17.

44. Corbin, Henry, *The Man of Light in Iranian Sufism*, 1971, Nancy Pearson trans, New Lebanon, NY: Omega Publications, 1994, p 5.

45. Axworthy, *A History of Iran*, p 94.

Artistic Creativity and the Art of Subterfuge

Ahmad Karimi-Hakkak

Artistic Creativity
and the Art of Subterfuge
Ahmad Karimi-Hakkak

If you placed yourself somewhere in Tehran, the capital of Iran, sometime in the early 1930s, you would likely see a lot of face-lifting efforts throughout the city: old mudbrick walls that recall the history of Qajar Persia being razed to the ground, new government buildings being erected with facades designed by German engineers to recall the glory of pre-Islamic Iran, row upon row of pine trees being planted along a new north-south artery named Pahlavi Avenue after the new dynasty. The city and the country were certainly getting an upgrading called modernization. Beneath this surface, though, an antique culture which had managed to survive for thousands of years by taking refuge in all manner of subtle subterfuge through artistic productions of diverse sorts, was beginning to pull out the latest tricks from its magic box.

Now, if you were an Iranian of a certain age contemplating the above scene, you might also recall that some 30 years previously the people of the city—and the country—staged a revolution, first petitioning the Shah of the time for a House of Justice, then rising up to demand a constitution, and finally achieving a full-fledged revolution—the first in the Middle East—and putting a parliamentary system of government in place of the old despotic rule they had endured for millennia. The political system thus forged was called a constitutional monarchy; the parliament they set up, known as the Majles, entertained the ambition of becoming the ultimate arbiter of political affairs both domestic and international, and the people aspired to shed their skin of subjecthood and become modern citizens.

Over the succeeding three decades, the after-effects of the Constitutional Revolution of 1906–1911 would contribute both to the country's rising prospects and unforeseen problems. On the one hand, foreign meddling in the country's affairs not only did not cease, but actually began to press upon the country even harder. Neither the king nor the newly instituted Majles proved capable of fulfilling all the promises of the Revolution, with the result that an ineffective parliamentary state eventually gave way to a military strongman who would rule within the constitutional system the people had forged, but with an iron fist. On the other hand,

the discovery of oil, known locally as "black gold", gradually enabled the country to have the means to foster aspirations of all sorts. In the early 1920s, the army general the country had come to know as Reza Khan rose steadily in power, eventually to oust the old Qajar dynasty and become the new monarch Reza Shah Pahlavi. Meanwhile, the culture produced mechanisms of coping with the changing situation through biting satire and bombastic lampoons masquerading as brilliant poetry, and nightly news pamphlets known as *Shabnameh* (because they were thrown into people's homes under the cover of darkness) replaced the free press the original constitutionalists had imagined.

The new monarch gradually tamed or took out his intellectual opposition, overruled the parliament, and began to drive social and economic progress forward with a heavy dose of political oppression. Many of the old intellectuals of the Constitutional Era, including the country's best-known fiction writer Mohammad-Ali Jamalzadeh, literary scholar Mohammad Qazvini, and parliamentarian Hassan Taqizadeh, had already left the country, mostly to end up in Berlin where they managed to establish a more or less free press to publish their work and propagate their ideals from abroad. Some, like the constitutionalist intellectual and satirist Ali-Akbar Dehkhoda or journalist Ali Dashti, gradually gave up the struggle for parliamentary rule altogether, and at least one, a well-known parliamentarian and perhaps the country's best-known poet by the name of Mohammad-Taqi Bahar, took refuge in whatever creativity and scholarly research remained permissible; this after his friend Mirzadeh Eshqi, a radical poet, was murdered in broad daylight in his home.

On the surface, Iran's dilemma seemed to force its leaders into a choice between Westernization, in the sense of an all-out effort to imitate the ways of Europe, and a type of modernization that might take note of the country's cultural identity, respect its religious traditions, and remain faithful to its historical development. For many Iranian elites the path to a brighter future seemed to lie through as much cultural change as they could manage without pushing for greater political freedoms, and the man who understood this most clearly was Reza Shah's close confidante and trusted Prime Minister, Mohammad-Ali Foroughi. Under his leadership in the early 1930s, either in his official capacity as Prime Minister or as the closest adviser to the Shah, a programme of cultural renewal was envisioned and advanced. The first Iranian university was built in Tehran, an Academy of the Persian Language was created to supervise language reform, and an international scholarly conference was held to honour Abolqasem Ferdowsi (930–1010), the country's best known and most honoured national poet. Clearly, a new Iranian nation was emerging, primarily modelled after European nations with all the visible signs of modernity in place—all, that is, except a democratic political system. But was that all?

The literary arts were flourishing as well, albeit under a system of censorship that had to be satisfied or circumvented. While government-sponsored journals multiplied, not all of the country's best-known literary figures published their work in them. Nima Yushij (1897–1960), a modernist poet gaining more and more acceptance, did serialize his theoretical magnum opus, *The Value of Feelings in the Lives of Artists*, in one such magazine, but the country's best young fiction writer, Sadeq Hedayat, wrote his now famous novella, *The Blind Owl*, a true masterpiece of an embryonic modernist Persian literature, in anonymity in Mumbai, India, and distributed hundreds of copies of the unpublished manuscript among his friends inside Iran. This may have been a solitary gesture of protest against Reza Shah's regime and the intellectual community that had been cornered or co-opted by it, but it was a first! Certainly, the Iran of the 1920s and 1930s does not offer a record of cultural achievement to match its imposing new physical renewal.

It is to the next crossroad in Iran's history, to the next generation of artists—a crowded mass of prophetic poets and misty-eyed mystics, of militant mourners and rebellious renegades—that we must turn to view something of the fullness of Iran's artistic scene in the twentieth century. While it is a complicated venture to posit a straightforward relationship between a freer social climate and heightened intellectual and artistic activity in any given society at any given time, the case of Iran in the 1940s and beyond is fairly clear. To replace a seasoned strong man like Reza Shah, shaped in the crucible of the post-Constitutional Revolution climate in Iran with a slender 22-year-old man educated in Switzerland and interested more in fast cars and beautiful women than in the affairs of the state, to relax many of the rigid rules pertaining to sartorial choices, and to release all those political prisoners into the society at large is bound to open up the social milieu in positive ways and make culture more visible, and it did.

Those occupying the political centre ground of Iran after the Second World War—poets like Ahmad Shamlu (1925–2000), Mehdi Akhavan-Saless (1928–1990), and Forugh Farrokhzad (1935–1967); and fiction writers like Sadeq Chubak (1916–1998), Jalal Al-e Ahmad (1923–1969), and Simin Daneshvar (1921–2012)—could best weave strands of social and political concerns into the texture of their work, each in his or her own particularly subtle and significant way. Much like the calligraphers, painters and sculptors of this generation or immediately succeeding them—artists like Bahman Mohassess (1931–2010), Hossein Zenderoudi (b. 1937), and Parviz Tanavoli (b. 1937)—they did, of course, deal in artistic abstractions, but in their work connections between art and idea were more or less readily accessible. Historically speaking, and with all due respect to earlier individual innovations and inventions, it was the work of this latter group that signalled the gestation of a steady stream of modernist art being created by Iranian artists, whether in literature and poetry or in conceptual, plastic or performing arts.

Appealing primarily to the felt and the experienced, Shamlu confronted the social experience directly and imaginatively, without much reference to—or reverence for—traditional conventions. While sharing Shamlu's penchant for the real and the physical, Akhavan went further than any modernist poet in incorporating the classics of Persian poetry into the rich and lush idiom of his modernist compositions. In many ways, these two poets defined the boundaries of the new poetry in relation to the millennium-old tradition which it purported to overthrow or replace. Farrokhzad, the first female poet in the millennium-old tradition to give vigour and voice to the female condition, remains distinct from both, indeed from all other Iranian poets, classical and modern. In a lamentably brief poetic career of only 15 years, she redefined gender relations in Persian poetry's universe of discourse by expressing female carnal desires, articulating diverse social and political aspirations, and—in her latest work—taking quantum leaps toward a mysterious longing at once tender and transcendent.

Alas, Farrokhzad's most specific aesthetic contribution to the modernist tradition in Persian poetry has remained largely unexamined. In her later poems, the actor and the act, the image and the idea, are wedded together in such a way as to move her poetry further toward self-referential relations, and ultimately to undermine externality as a signifier of relevance. The most famous example of this union comes in an image the poet sets before us as she intimates the idea of her mortality, paving the way for articulating the possibility to approach artistic ideas by contemplating images, in this case remembering the image of a bird in flight:

The bird who had died
taught me to keep on flying
[...]
Remember the flight,
the bird is a dying thing.

In thus preserving the memory of the bird in the act of flying, its most essential attribute, Farrokhzad foregrounds the fundamental unity of being and doing. What appears on the surface to be a distinguishing strategy, whereby the act is established as superior to the emblem, leads to a rhetorical command concealing a far more probing question: is it not impossible to have one without the other? Underlining that impossibility, the transient world of matter and the ideal of transcendence reveal the false choice initially implied. The bird and the flight serve as two modes for the existence of a single aspiration, provably possible.

Left to the latest generation of Persian poets, the rich and colourful legacy of old Persia's variegated artistic coping mechanisms, coupled with a store

of Iran's modernist literature, would express itself in certain visible trends in the poetry of the closing decades of the twentieth century. Beyond that, the latest literary works coming from Iran seem to unify the two most perennial aesthetic impulses of the classical tradition in Persian poetry—the verbal and the visual—in a unique synthesis of image and idea. Interestingly, and perhaps paradoxically, the largest number of Iranian writers welcoming the changes initiated or advanced by Farrokhzad and others came from the ranks of socially engaged poets. Poets like Manuchehr Atashi (1931–2005) and Mohammad-Ali Sepanlu (1938–2015), and fiction writers such as Mahmoud Dowlatabadi (b. 1940) and Hushang Golshiri (1937–2000), for instance, were quick to see in the new tendency the possibility of moving beyond the discourse of literary engagement toward a transcendent horizon where literature becomes itself once again.

These writers, as well as contrarians like Yadollah Roya'i (b. 1932), have contributed substantially to the move toward an image-driven literature. Having held their ground for the autonomy of the literary reference through the decades of the 1950s and 1960s, when the idea of literary engagement held sway, the latter felt fully vindicated only after the Iranian Revolution of 1978–1983. As the most accomplished advocate of art's autonomous kingdom even in the heydays of literary commitment, Roya'i remains the most noteworthy contributor to the progress of imagistic poetry. A poet with a phenomenally bold imagination and a deep appreciation of the poetic image, he took new strides in his Parisian exile toward producing a poetry of pure image. In *Seventy Tombstones*, first published in 1998, he moves even more toward featuring a sense of the pure image, unprecedented in Persian poetry. As the name suggests, the book features a series of imaginary tombstone inscriptions, each occupying a single page of the book and each made up of two parts: a prose passage and a corpus in verse indistinguishable from the prose but for the arrangement of the lines on the page. In offering the poem entitled "Martyr's Stone" below, I will try to preserve a semblance of this visual presentation:

A sketch of Zarathustra's smile upon the stone. A thin tablet (the vertical inscription on the tombstone) to be carved in the shape of a wave, from a marble different from that of the tombstone. Grass has grown all around the grave—and in the grass, a hatchet, upon the staircase to the altar down which he rolled, as he said under his soldier's blow: that we should not be is another form of our being.

You who on the front line
put your life on the line in front,
may my world be foam, a blade of straw, on your heaving forth!

And may your beauty forever
be the size of our lives!

In Roya'i's poems, we can say that subterfuge goes underground. The poem celebrates the courage of convictions that led so many Iranian martyrs of the Revolution and the Iran-Iraq War of the 1980s in various struggles, all to preserve some deeply held ideals, sometimes one against the other. The poet associates the reward of the blissful life that martyrs receive with Zarathustra, the ancient prophet reputed to have been born smiling and who is now revered as the only truly "Iranian" prophet, rather than with the late Shah of Iran or Ayatollah Khomeini, the revolutionary leader who dispatched so many Iranian revolutionaries to their demise. In doing so, he bestows immortality upon the martyred heroes of the Revolution and the War, while at the same time registering his protest against the culture of death propagated by two succeeding states. Thus, beyond all relevancies that might accrue to various sorts of external references, the poet demonstrates the possibility that poetry can be image-centred and relevant at one and the same time.

A different approach to restoring the unity of the image and the idea came only one year later from an unexpected, though not surprising, source: the world famous Iranian filmmaker Abbas Kiarostami (b. 1940). As a rather late bloomer in poetry, he must be classed with a generation of poets much younger than himself, as his first collection of poems, *Walking with the Wind,* appeared in Tehran in 1999 when he was almost 60 years old. In this oddly shaped book of short haiku-like poems, Iran's master filmmaker responds to a whole number of previous compositions on the complex relationship between word and image in Persian poetry. His deliberate avoidance of terms already designated as poetic underscores that intention; his thematic choices make the poems read like calculated responses to the canon of modernist Persian poetry in Iran.

In other ways too, Kiarostami appears insistently to direct poetic images toward potentials which he perceives as hitherto untapped. The ultimate impression his poems leave is that he has set himself the task of liberating the reader from the last remaining vestiges of previously imagined linguistic linkages between poetry image and verbiage. We can imagine him in an attempt to articulate a conception of the image as something between those metaphors and similes that verge on the cliché and something wholly new, a vision that extends to the shape of the book and the placement of a single poem on each page. As the reader leafs through the book, which is longer across the pages than along the spine, and ponders the few lines that form each poem, an inevitable sensation arises that the filmmaker-turned-poet is adding a final metaphor: that of a poem as a single frame and the book as a feature film.

A closer look at some of Kiarostami's poems confirms the assumption that he conceptualizes poetry and film as ontologically one and the same. Personages of *Walking with the Wind* come from an array of contexts, the most evident being fauna and flora. Some generic, others quite specific, some making a single appearance, others practically everywhere, his verbal images bear a clear resemblance to the artwork featured in the exhibition and in this catalogue. Plenty of animals are present in his poems too: the foal, the nag, and the horse; pigeons and doves and wild geese; butterflies and grasshoppers; a mosquito here, two dragonflies there, spiders everywhere; honeybees and worker bees and queen-bees; lizards and snakes and turtles and spiders; running dogs and dying dogs, village dogs and stray dogs, dogs barking and dogs dozing. In one poem we see a snake crossing the street while in another a bitch responds to a she-jackal. In one, a worm exits one apple only to enter another, while elsewhere a sweet-water trout determinedly moves toward certain death in the salty waters of the sea.

These and many other poetic personages appear more or less as phenomenologically direct manifestations of a specific order of being, as plants are of another. The pine and the box-tree, the sycamore and the oak, the mulberry and the cherry (particularly the cherry), the weeping willow and the towering cypress, all grow and decay side-by-side with the rattan, the cotton, the poppies, the violets, the bignonia. In such plentiful settings nuns young and old move seemingly directionless, mostly arguing and disagreeing as small children play meaningful games. Nearby, pregnant women cry next to their sleeping men and soldiers march to and from unnamed battlefields. Meanwhile, the scarecrow acts and is acted upon in every conceivable way except for scaring the crows, a snowman melts under the wishful eyes of a child nursing a fever, and a doll is handled far more gently by the child than by the mother. At the centre of the book, as the narrator's companion, the wind impresses us as an invisible presence, a vocable of breathing, an echo of a voice that seems to be saying: I will be your guide, pilgrim; I am vast and invincible. Move with me, let me calm your fears and lead you away from the anguish of daily life.

I have selected one particularly poignant poem, number 100, from among this vast variety of images and actors through which to argue for the evolution of the idea of imagistic poetry in the Persian tradition of modern Iran:

From far away a dandelion
deigned to settle on the pond
without rippling the water.

Those familiar with Iran's modernist poet Mehdi Akhavan-Saless may easily see how Kiarostami is responding to Akhavan's poem "Qasedak" (Dandelion), written almost half a century before. The strategy is not unlike the way a single frame functions in a full-length film: rather than allowing words to relate to an idea in the social context, he allows his image to enter into a dialogue with the concepts communicated by previous poets. Unlike the dandelion in Akhavan's poem, Kiarostami's does not disturb anything, least of all the onlooker witnessing the calm, deliberately inconsequential way in which it settles on a pond's still water.

Future historians of Persian literature, particularly in the art of poetry, may well focus on our time as one in which Persian poetry made itself new in such ways as to begin to regain much of the glory it once possessed. It is entirely possible to envision a future for Persian poetry in which it might be able to graft its newfound strength—in the ideas it proffers, in the expressive strategies it foregrounds and above all in the imagery it creates—to the eternal and universal human need for emotive responses, be they psychic, social or erotic. As a living and growing aesthetic tradition, the Persian poetry of the twenty-first century in Iran, in Afghanistan and Central Asia, or in the many Persian diasporas around the world, may well extend its domain farther and wider than it has thus far. The outlook for Persian poetry appears to be as bright in the second millennium of its existence as it was when such foundational poems as the grand epic known as the *Shahnameh* and Nezami's romances, the lyricism of Omar Khayyam's *Rubaiyat* and the dense lyrical outbursts of Rumi or Sa`di, and the deep contemplations of Hafez or Bidel, gave this tradition its universal appeal.

Works from the
Mohammed Afkhami Collection

Shiva Ahmadi

Oil Barrel #13, 2010

oil on steel
73.6 × 53.3 cm

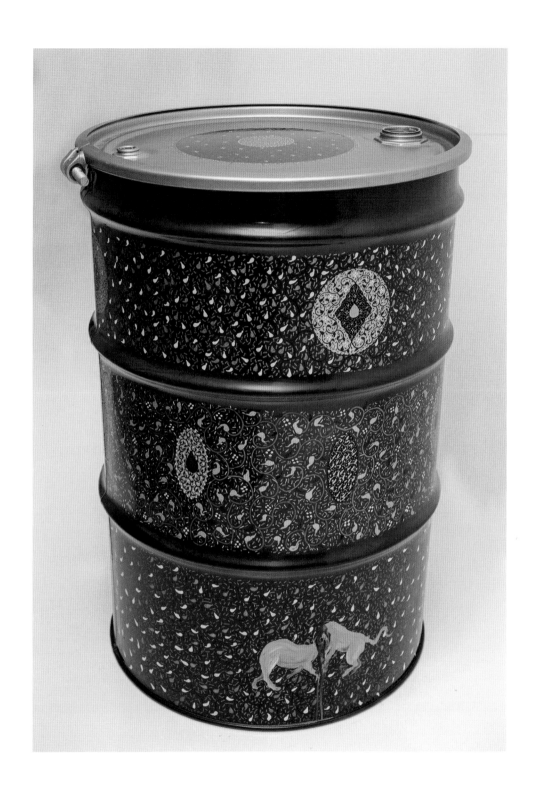

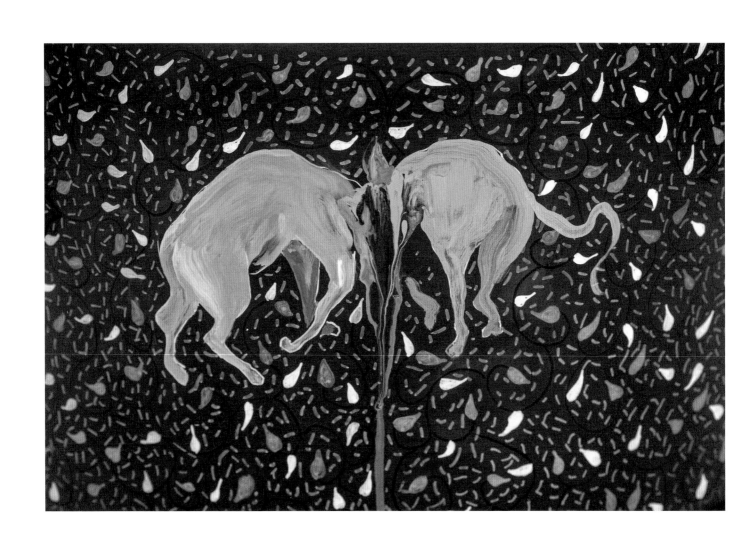

Shiva Ahmadi

Morteza Ahmadvand

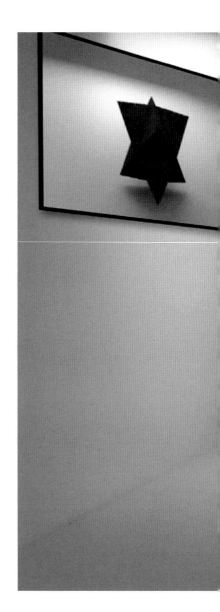

Becoming, 2015

video installation and fibreglass sphere
sphere diameter 100 cm
dimensions of room variable

Shirin Aliabadi

Miss Hybrid 3, 2008

C-print
154 × 123.5 cm

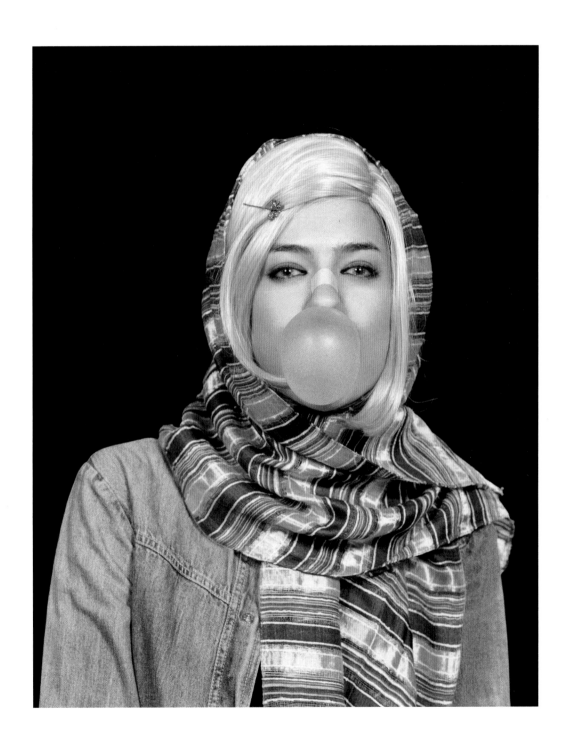

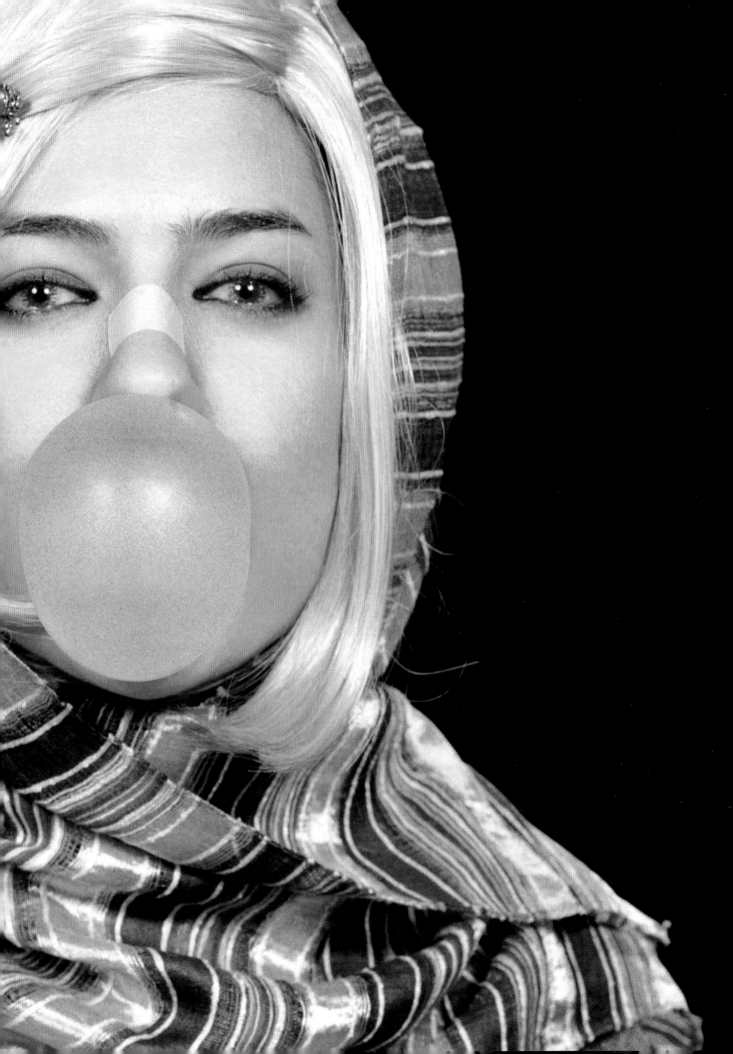

Afruz Amighi

Angels in Combat I, 2010

woven polyethylene, Plexiglas and light
251.5 × 165.1 cm

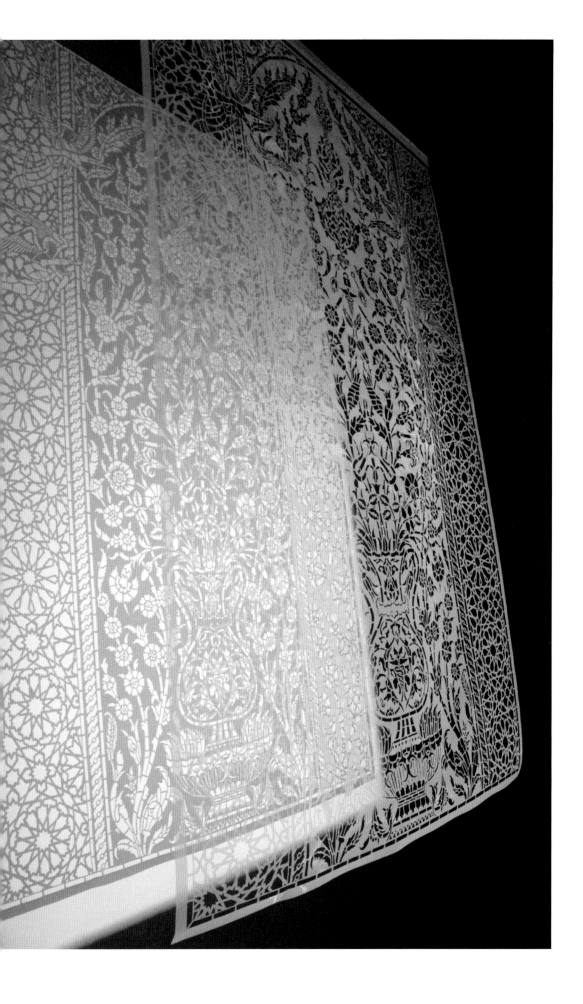

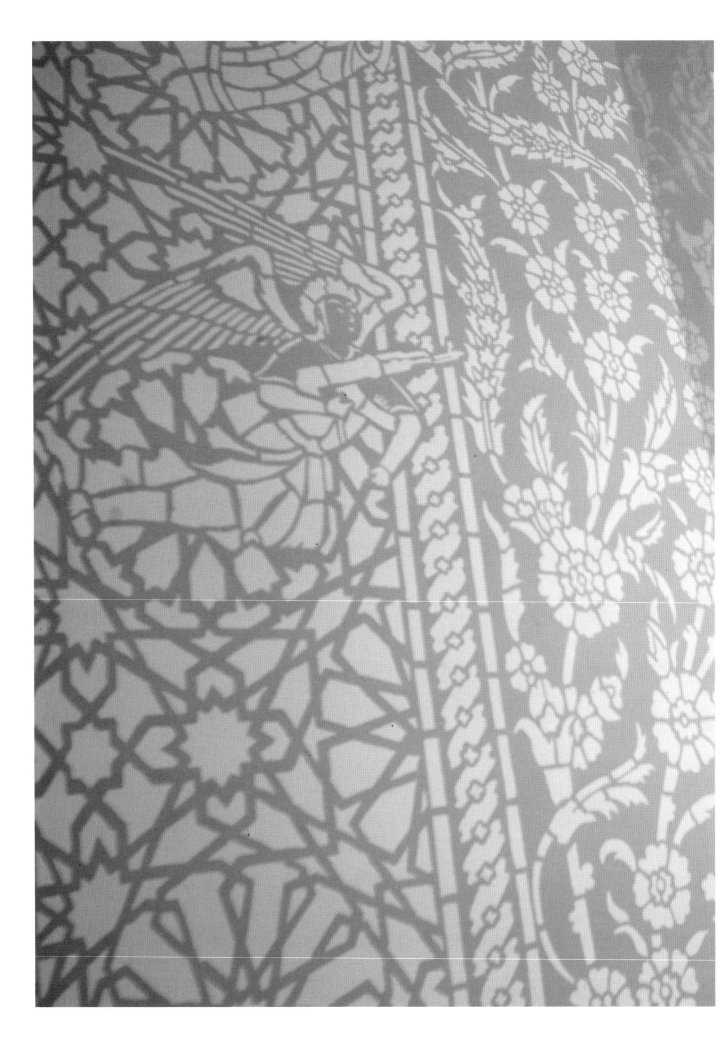

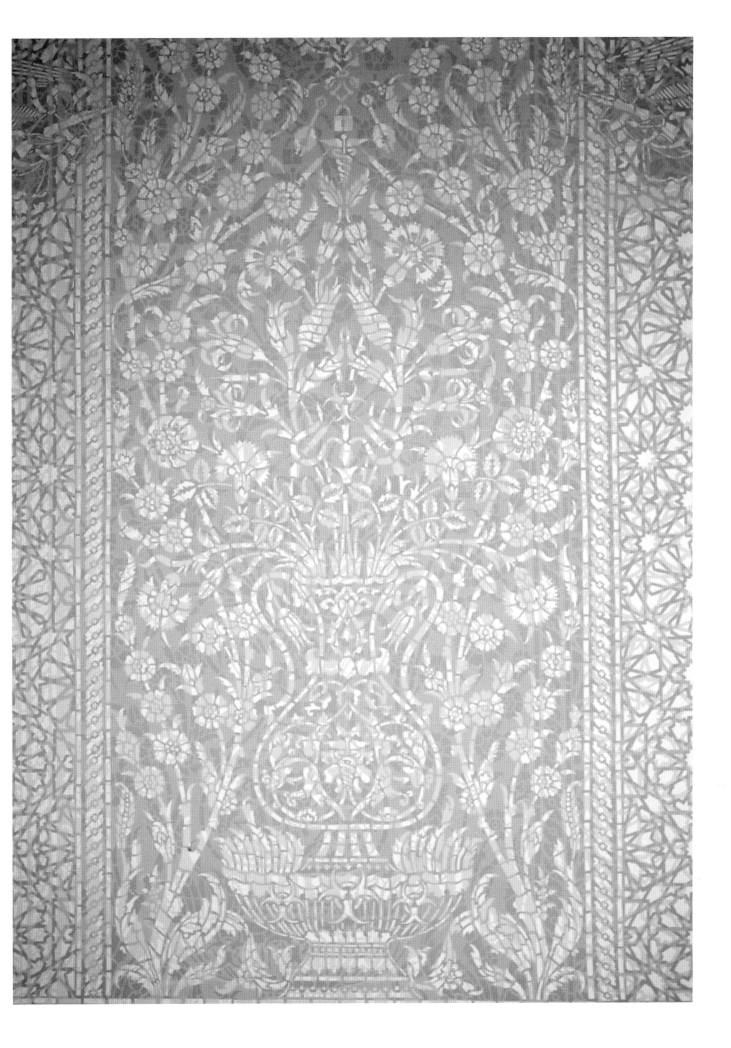

Nazgol Ansarinia

Pillars: Article 47, 2015

epoxy resin and paint
65 × 35 × 35 cm

Nazgol Ansarinia

Untitled II
(*Pattern* series), 2008

ink drawing and digital print on paper
four panels 91 × 111 cm each
total dimensions 235 × 193 cm

Mahmoud Bakhshi

*Tulips Rise from the Blood of
the Nation's Youth* (*Industrial
Revolution* series), 2008

neon, tinplate, wood, plastic, and
electric engine
three sculptures 135 × 35 × 30 cm each

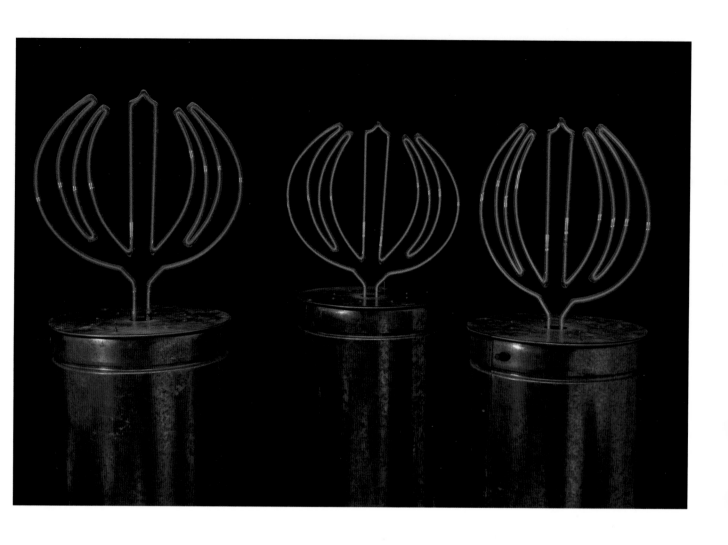

Ali Banisadr

We Haven't Landed on Earth Yet, 2012

oil on linen
208.3 × 304.8 cm

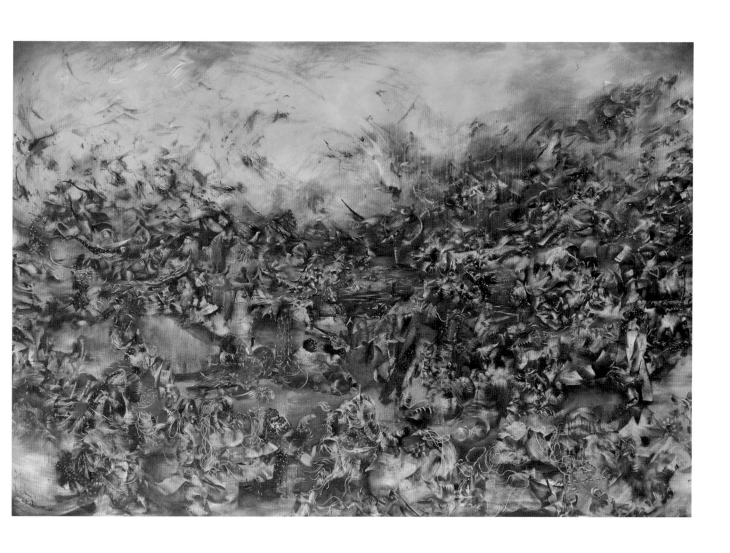

Alireza Dayani

Untitled
(*Metamorphosis* series), 2009

ink on cotton rag paper
150 × 400 cm

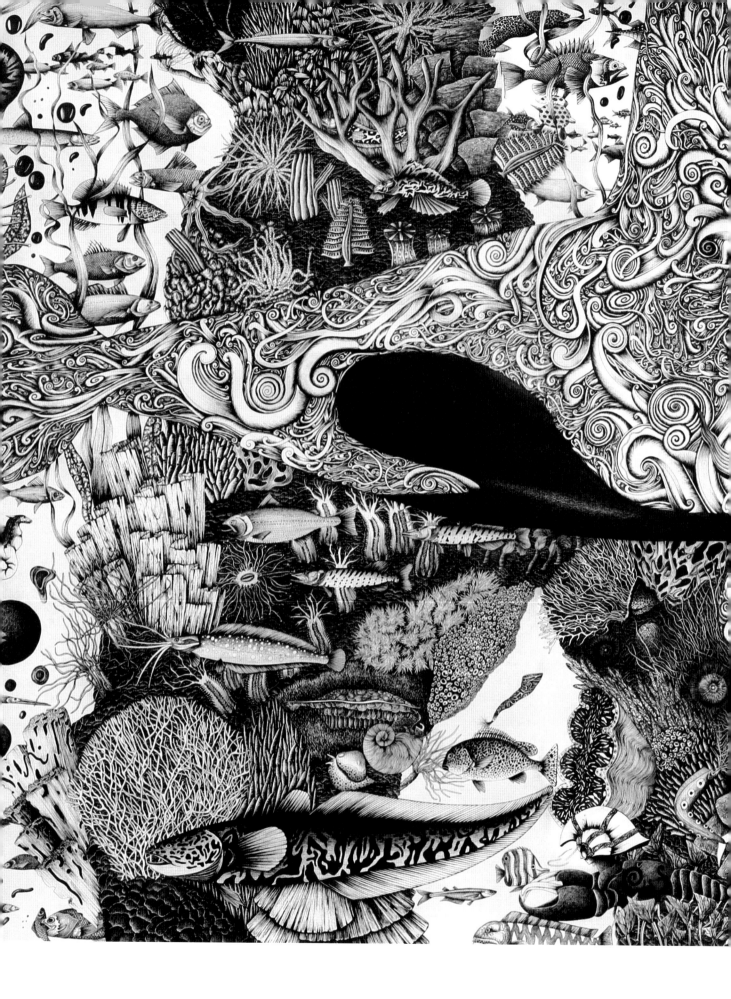

Alireza Dayani

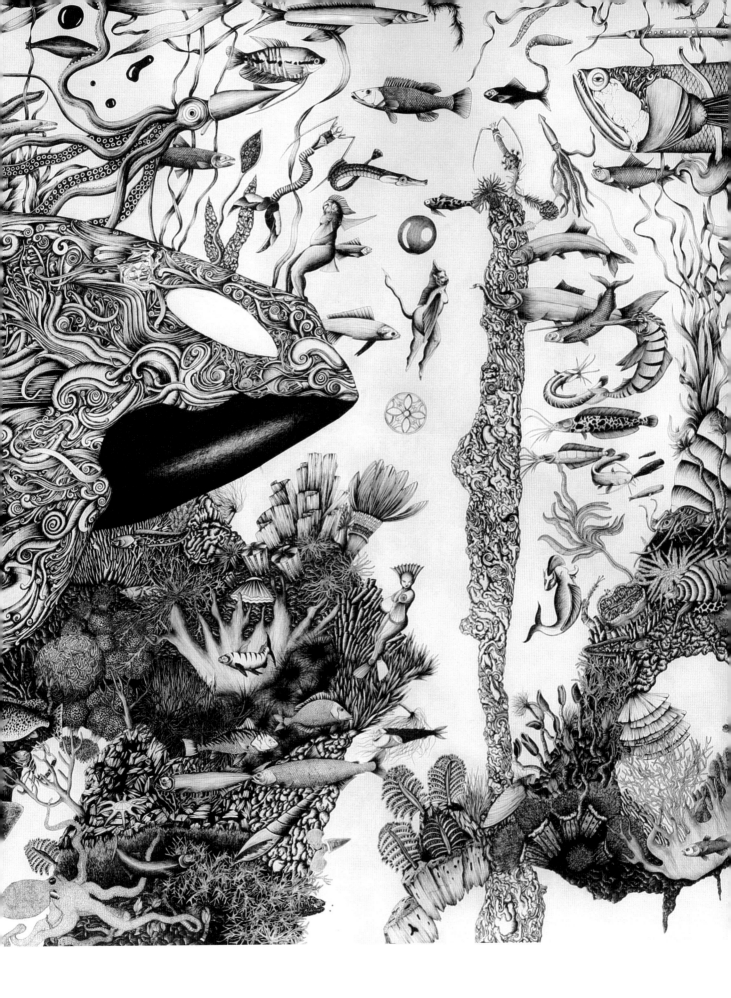

Mohammed Ehsai

Mohabbat (Kindness), 2006

oil and silver leaf on canvas
157 × 157 cm

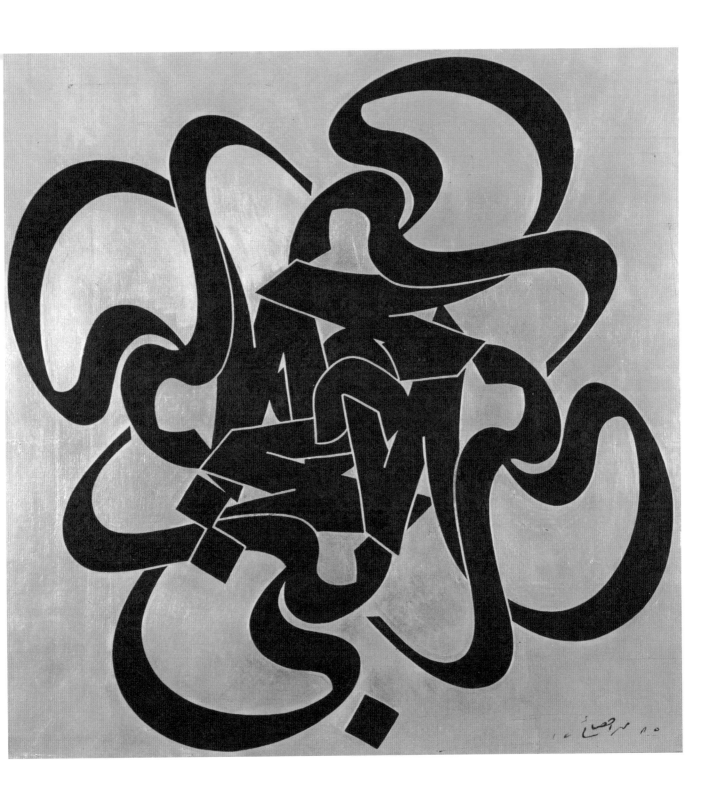

Monir Farmanfarmaian

The Lady Reappears, 2007

mirror
150 × 80 cm

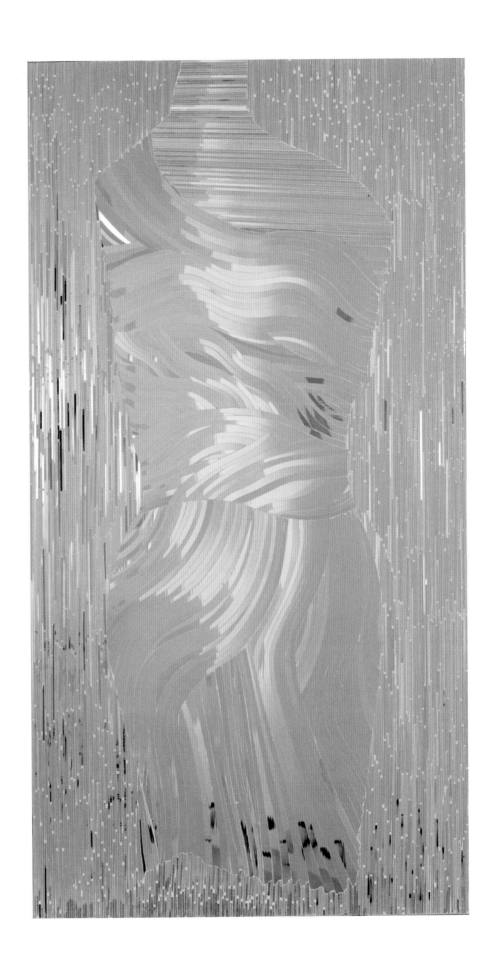

Parastou Forouhar

Friday, 2003

C-print mounted on aluminum
four panels 170 × 86 cm each

Shadi Ghadirian

Untitled #10
(*Qajar* series), 1998

C-print
90 × 60 cm

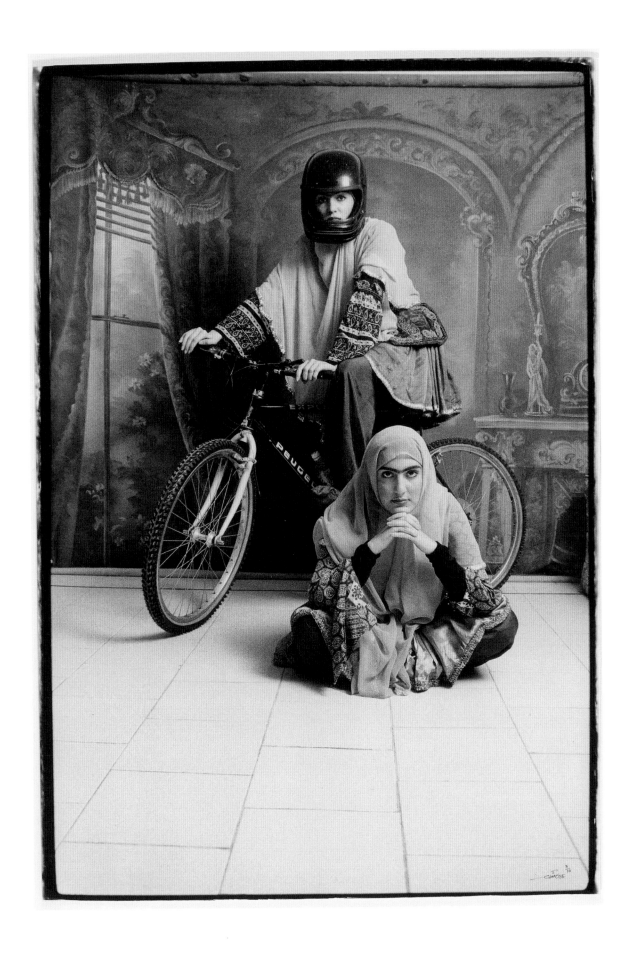

95

Shadi Ghadirian

Untitled #11
(*Qajar* series), 1998

C-print
90 × 60 cm

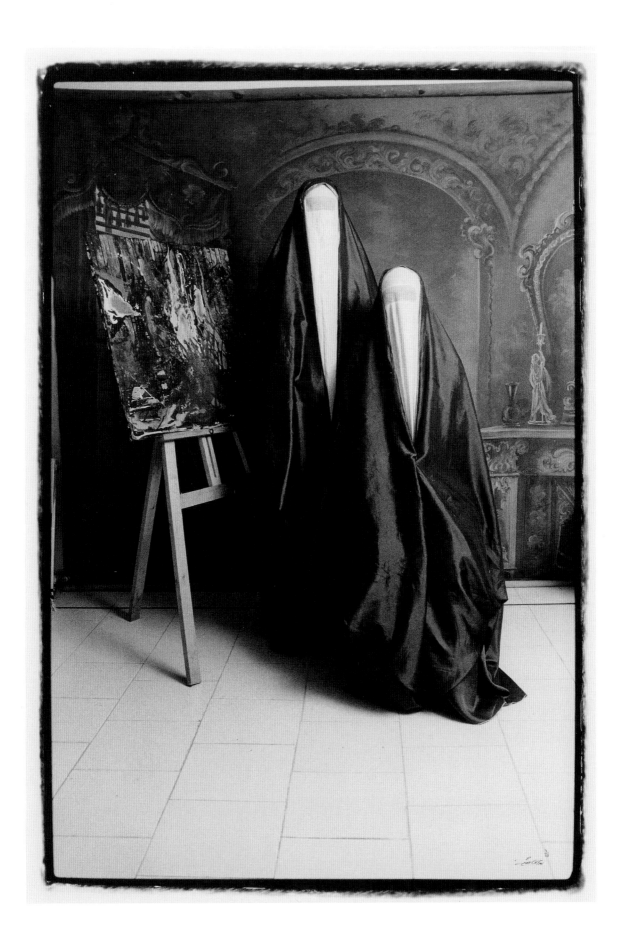

Rokni Haerizadeh

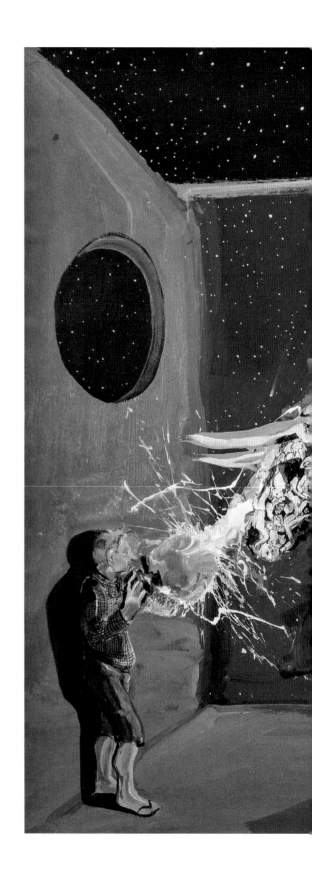

*We Will Join Hands in Love
and Rebuild our Country,* 2012

watercolour and acrylic on paper
90 × 122 cm

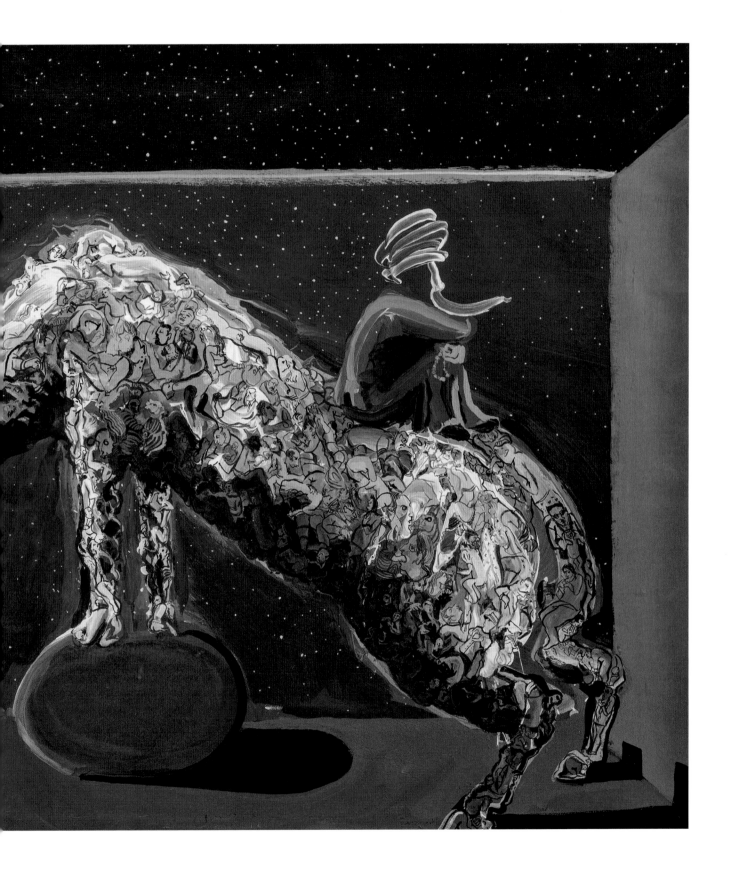

Rokni Haerizadeh

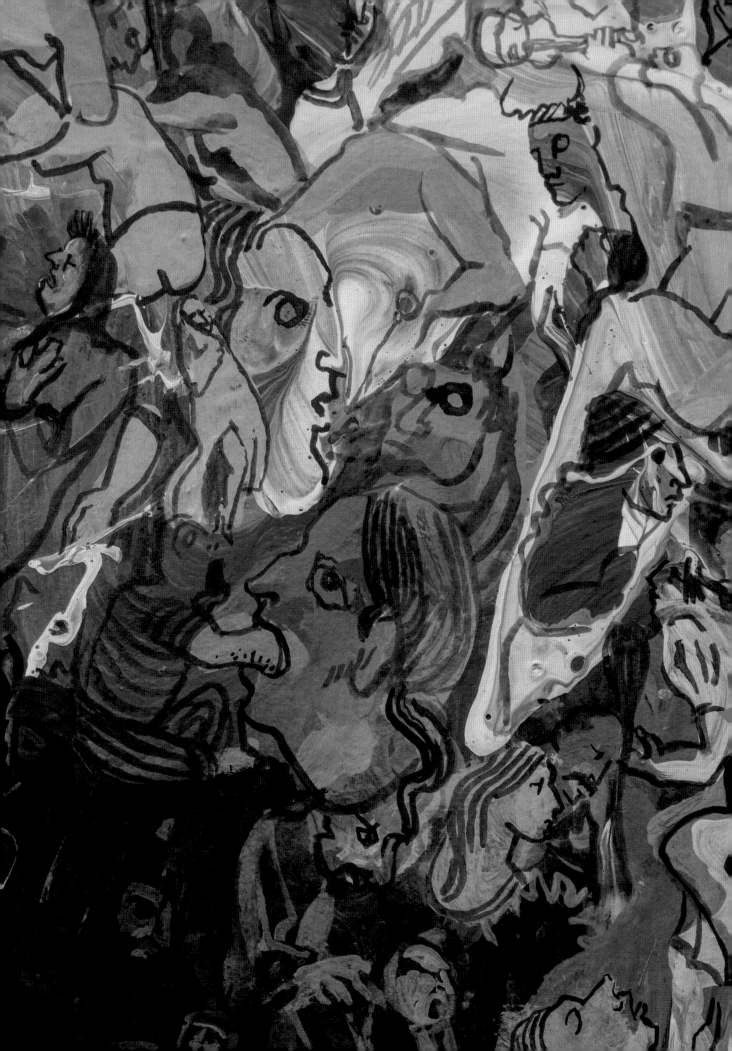

Khosrow Hassanzadeh

"ترور ی ست"

خسرو حسن زاده

ملیت: ایرانی

مذهب: مسلمان

سن: چهل و یک ساله

شغل: هنرمند نقاش

مشخصه: بندانگشت نشانه دست چپ قطع شده است.

سوابق: خسرو چند نمایشگاه هنری با موضوع مذهبی و فرهنگ مردمی

در ایران و خارج از کشور داشته است.

او در تهران زندگی می کند و صاحب دو فرزند می باشد.

"TERRORIST"
KHOSROW HASSANZADEH
NATIONALITY:IRANIAN
RELIGION:MUSLIM
AGE:41
PROFESSION:ARTIST
DISTINCTIVE TRAITS:
MISSING TIP OF LEFT FOREFINGER.
PERSONAL HISTORY:SEVERAL EXHIBITIONS
BOTH IN IRAN AND ABROAD. MOST OF HIS
ARTWORK MAKES USE OF RELIGEOUS MOTIF

Terrorist: Khosrow, 2004

acrylic and silkscreen ink on canvas
250 × 205 cm

Detail: Replica of identity certificate
cardstock and gold foil
silkscreened in 2016

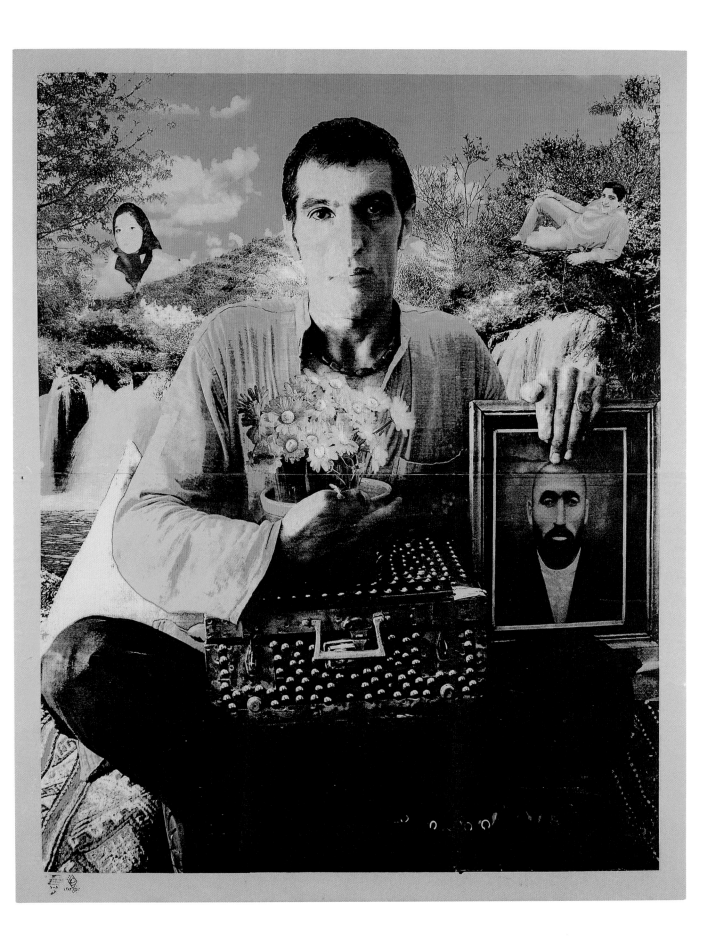

103

Shirazeh Houshiary

Memory, 2005

white aquacryl, blue pencil and gesso
on canvas
190 × 190 cm

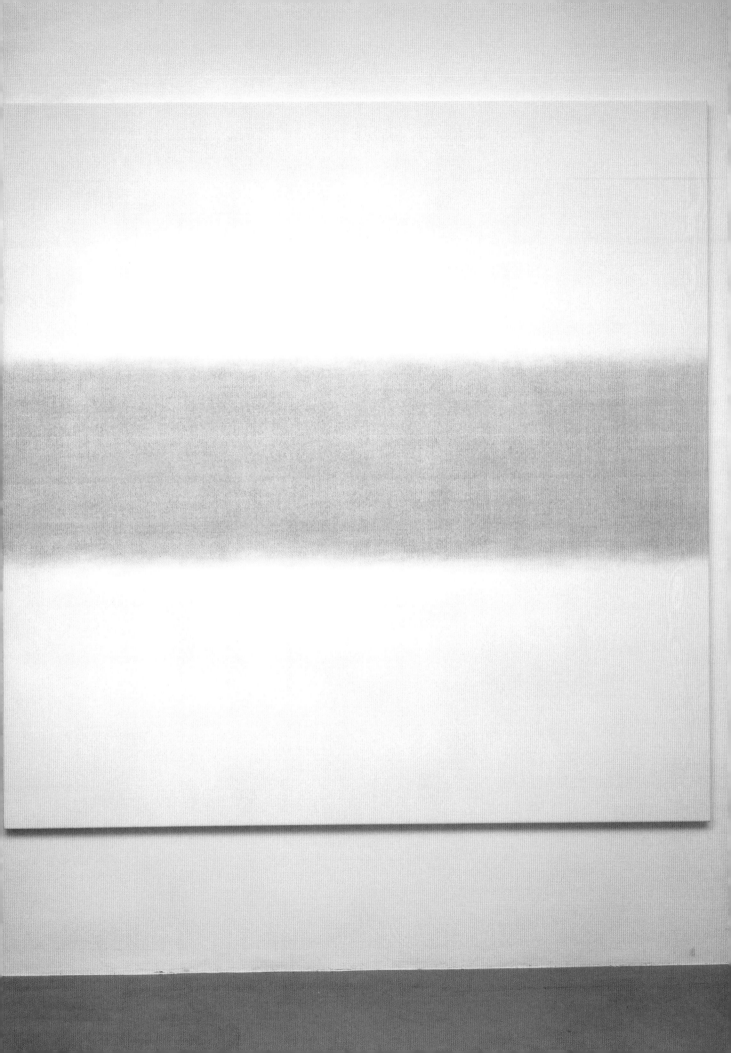

Shirazeh Houshiary

Pupa, 2014

amethyst glass and mirror polished
stainless steel
116 × 87 × 48 cm

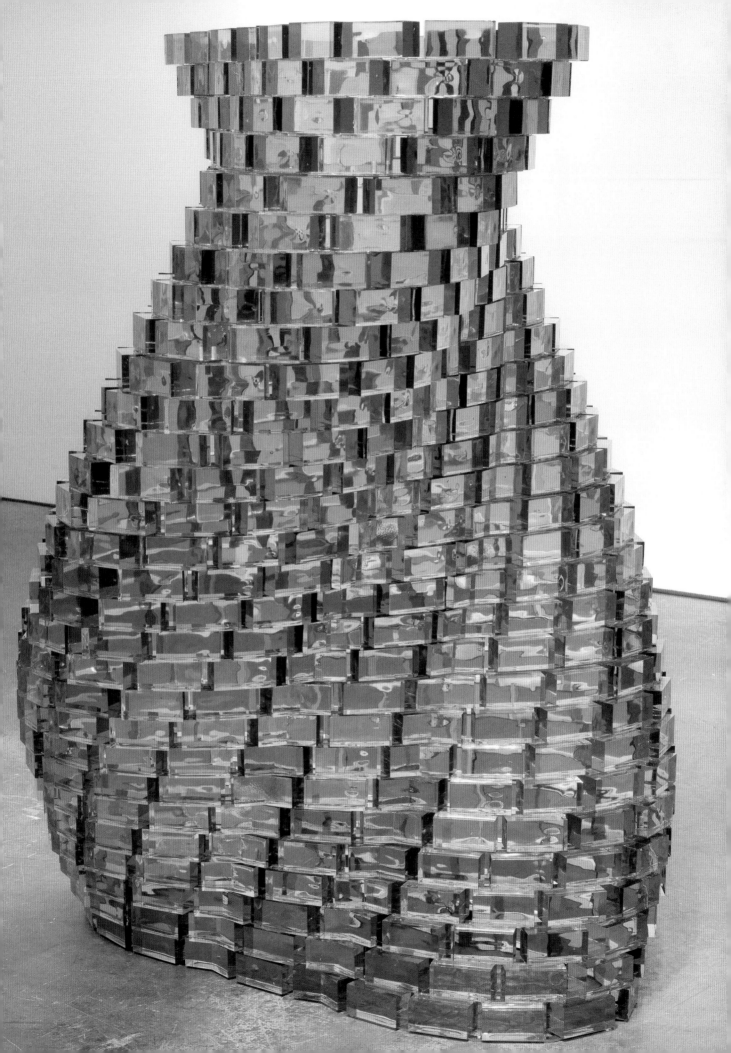

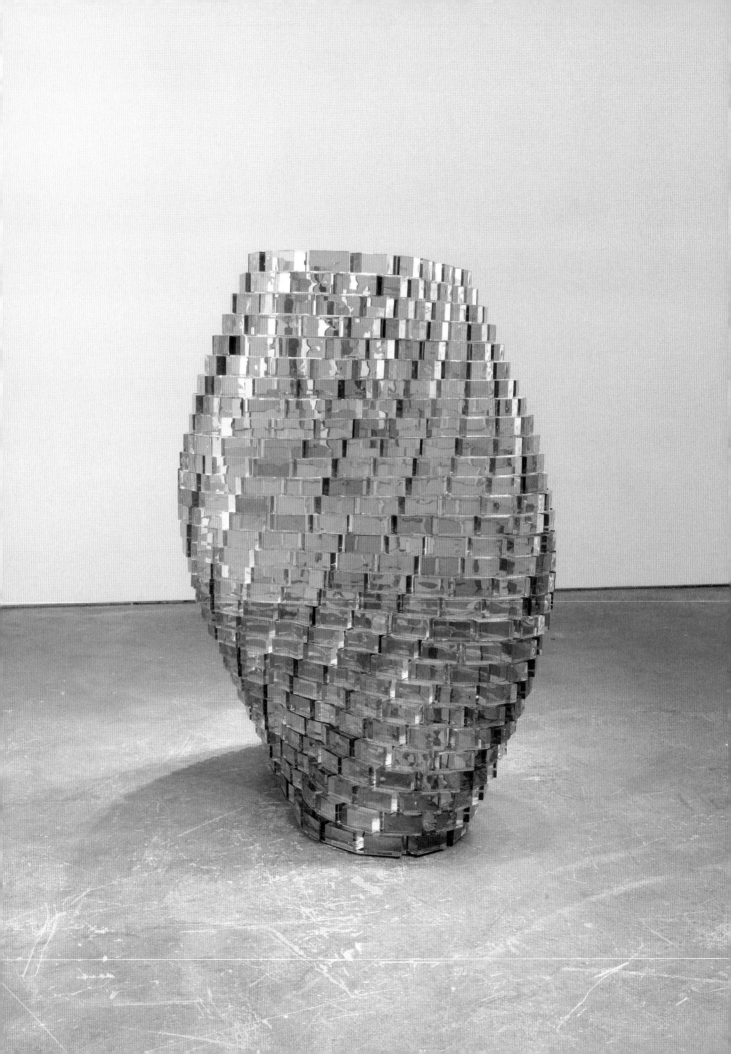

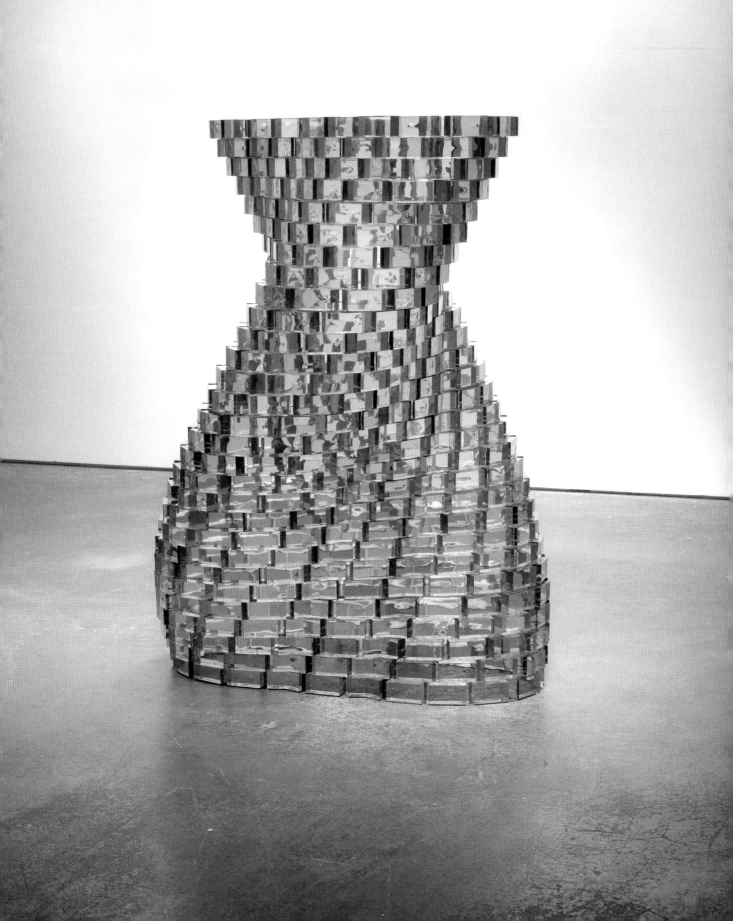

Y.Z. Kami

Black Dome, 2015

black gesso on linen
177.8 × 195.6 cm

Abbas Kiarostami

Untitled
(*Snow White* series), 2010

photographic print on canvas
triptych 189 × 100 cm each

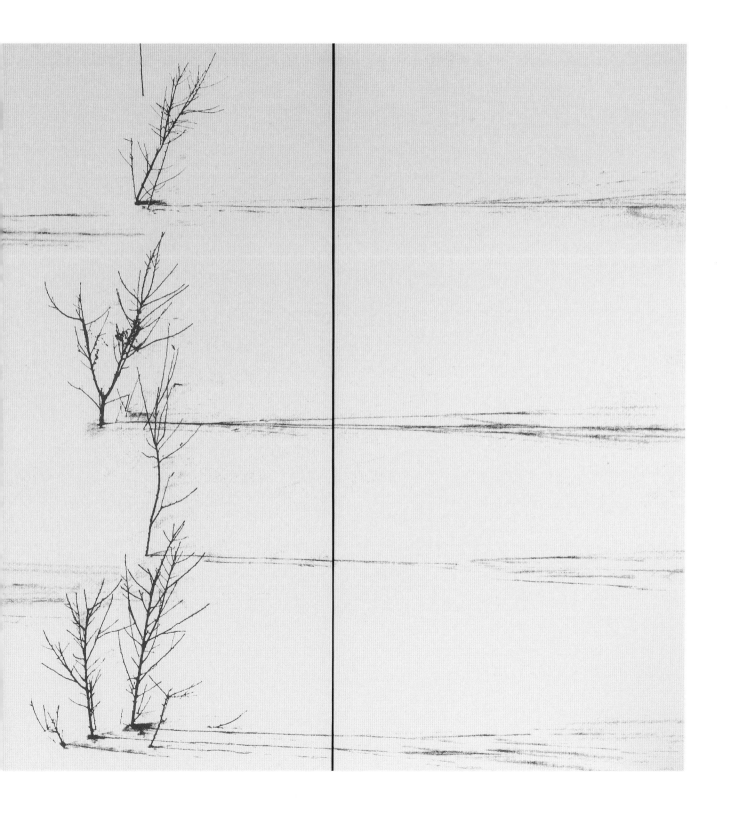

Farhad Moshiri

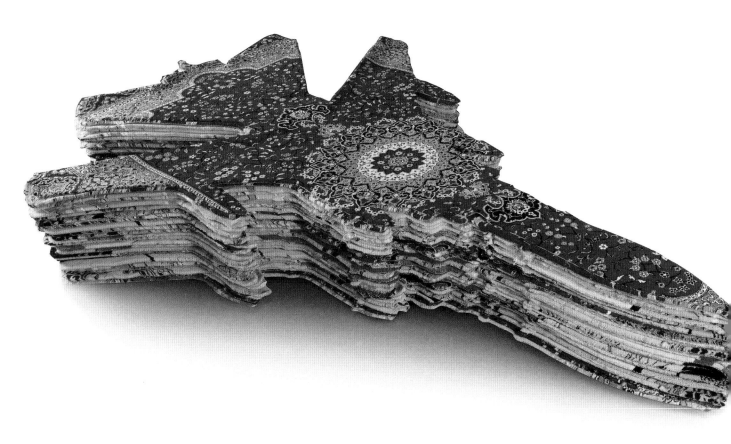

Flying Carpet, 2007

32 stacked machine-made carpets
edition of 3
fighter aircraft 275 × 180 × 44 cm
carpet stack 300 × 200 × 44 cm

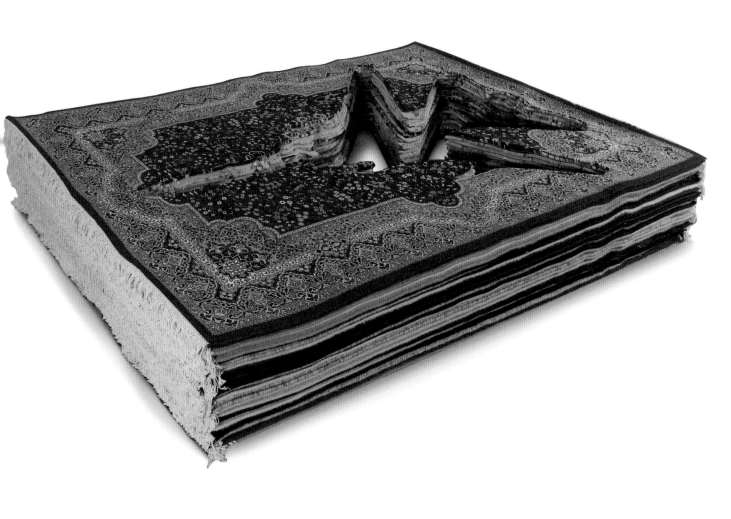

Timo Nasseri

Parsec #15, 2009

stainless steel
105 × 95 × 95 cm

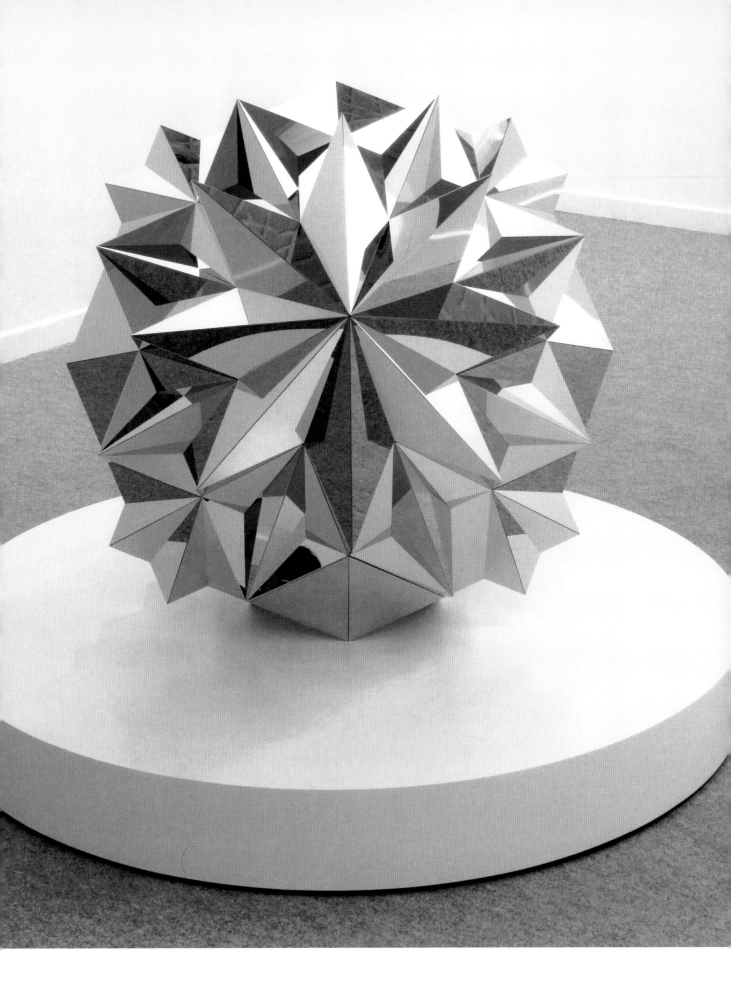

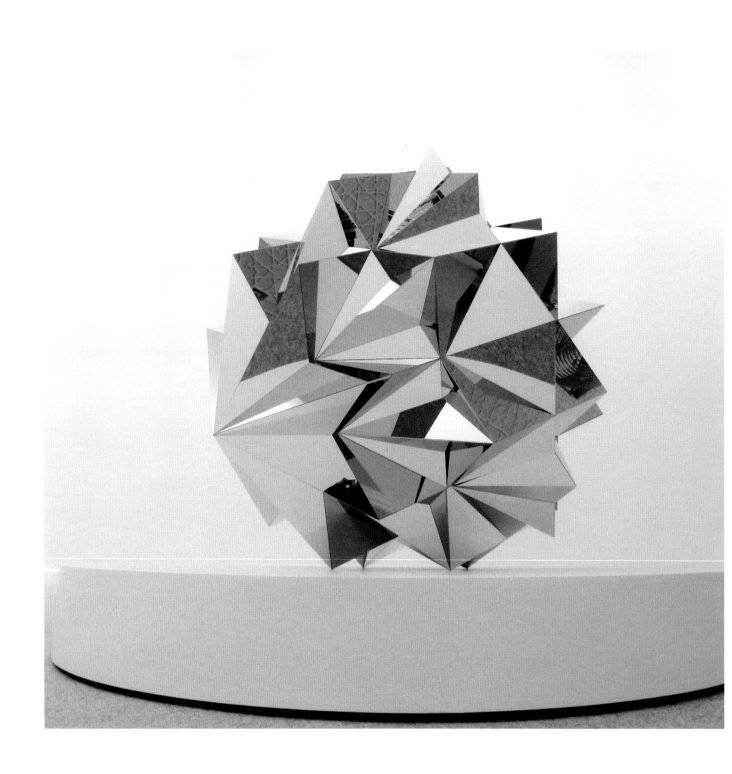

Timo Nasseri

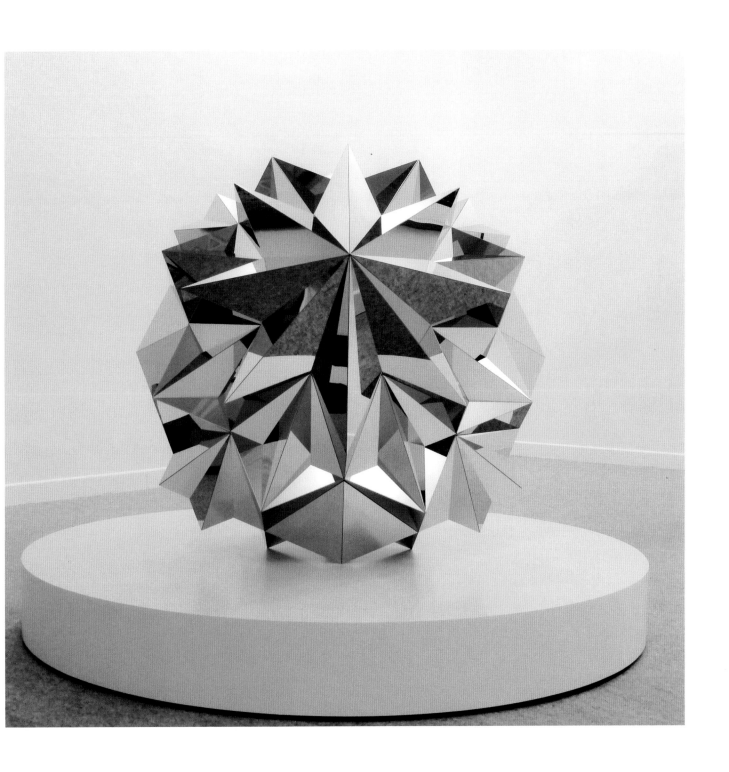

Shirin Neshat

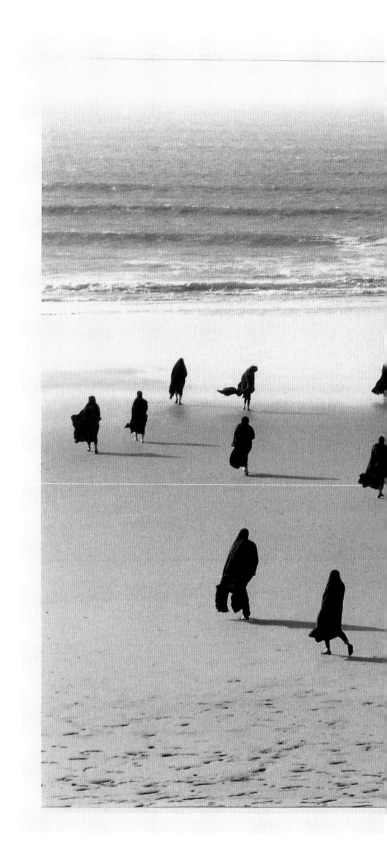

Untitled
(*Rapture* series), 1999

silver gelatin print
50.8 × 60.9 cm
2/10

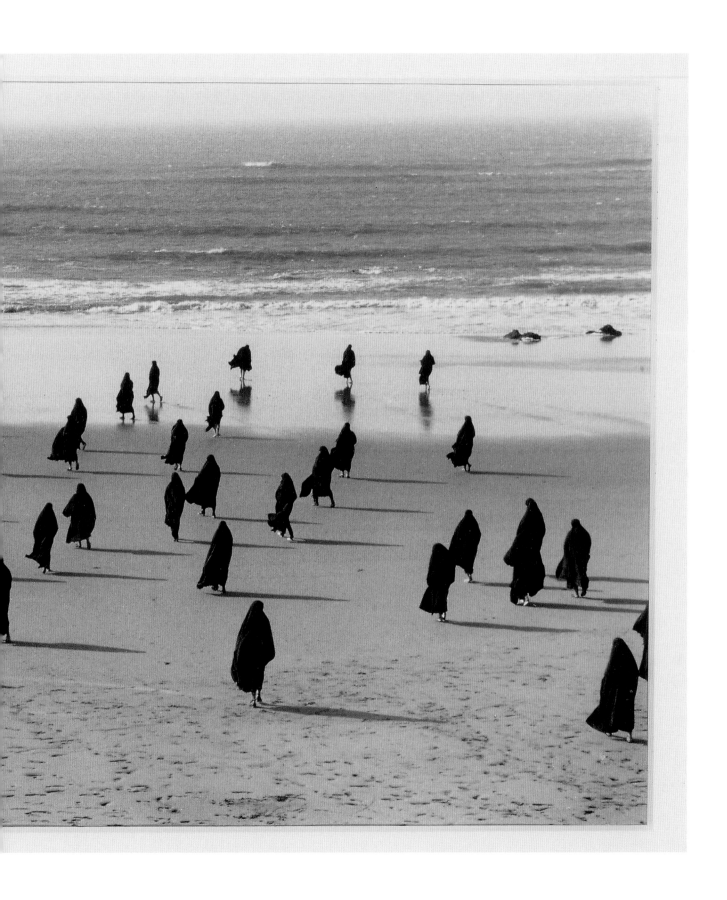

Shahpour Pouyan

Projectile 11, 2015

iron and steel
200 × 174 × 174 cm

Shahpour Pouyan

*Unthinkable Though*t, 2014

glazed ceramic and acrylic
dimensions vary from 35.5 × 25.5 cm
(*Iranistan*) to 10 × 28 cm (*Pantheon*)

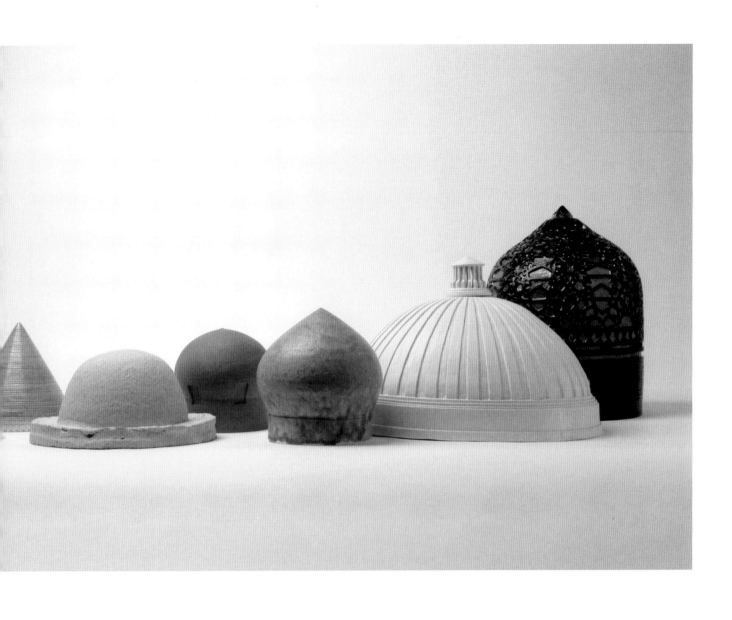

Hamed Sahihi

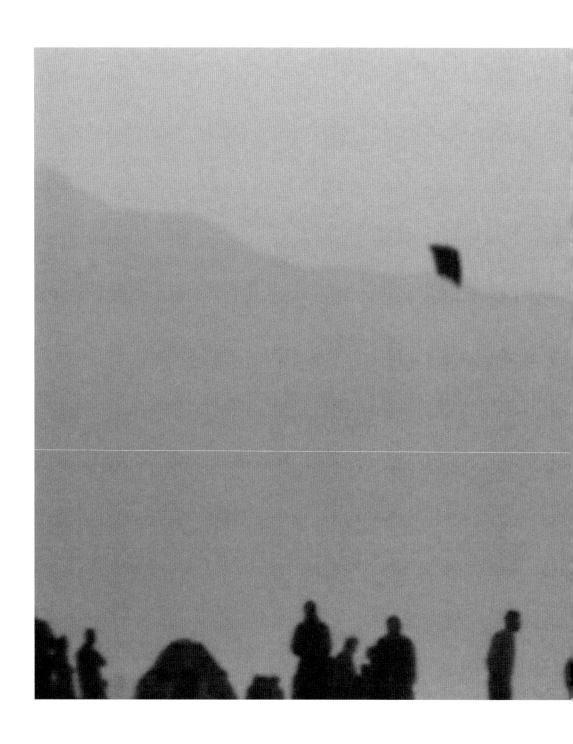

Sundown, 2007

video
3 mins, 30 secs

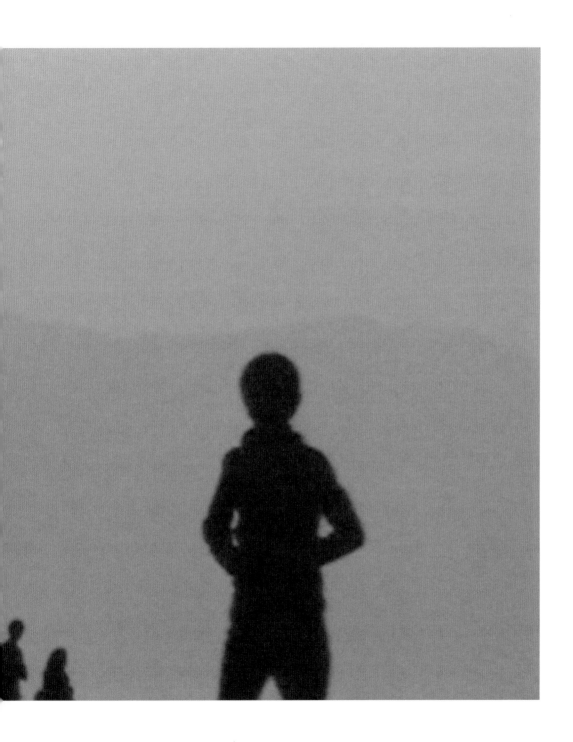

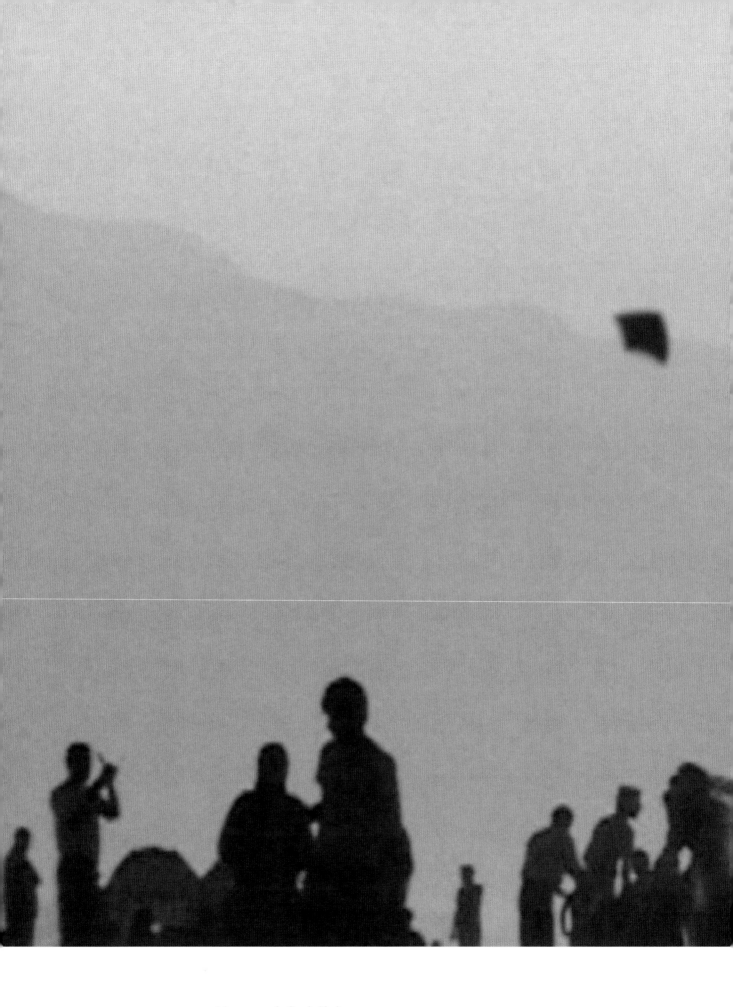

Hamed Sahihi

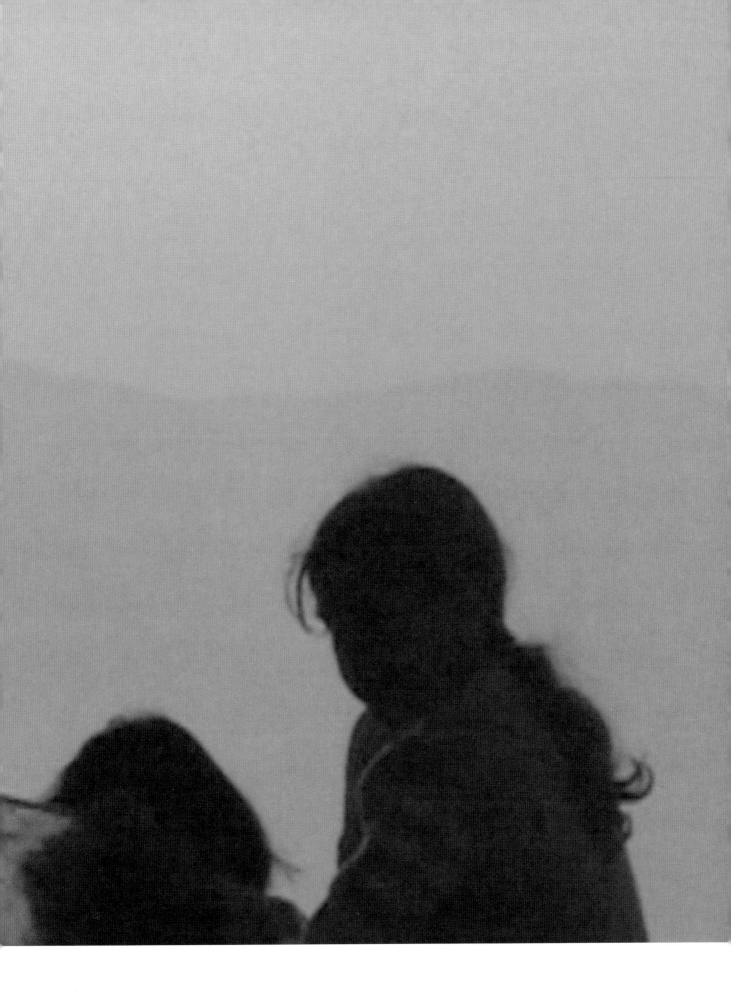

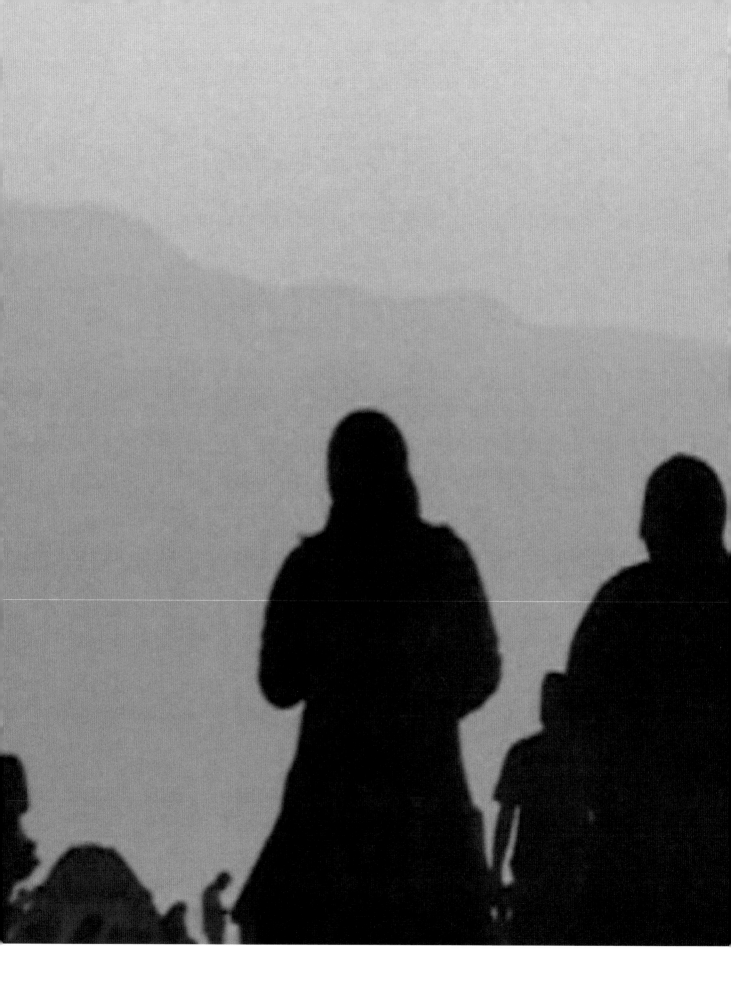

Hamed Sahihi

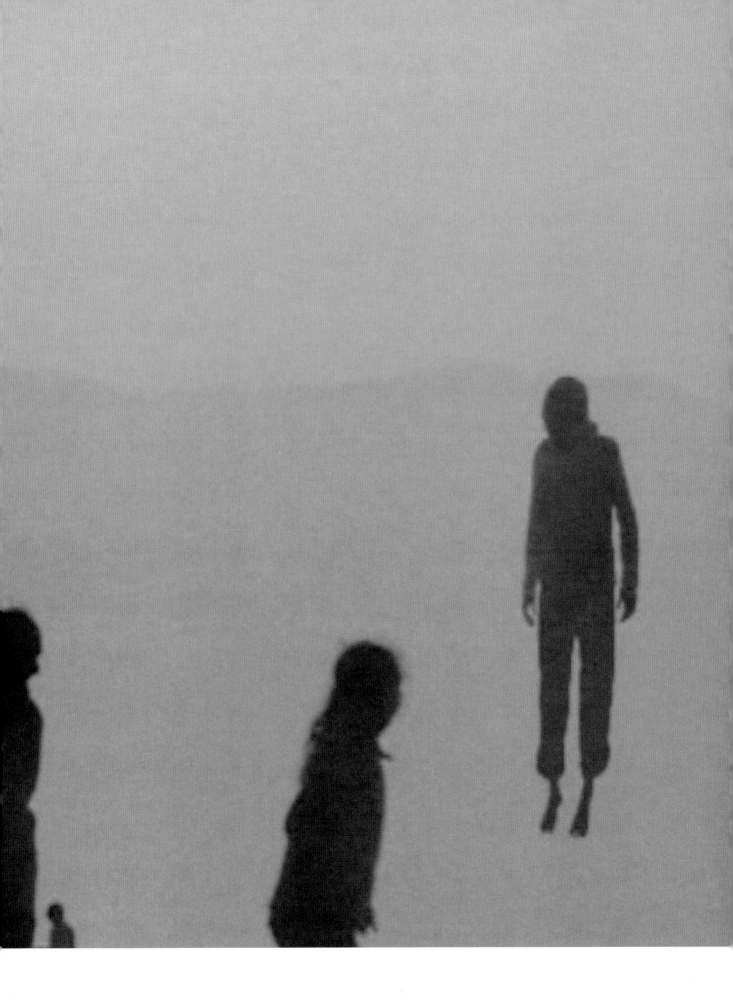

Parviz Tanavoli

Blue Heech, 2005

painted fibreglass
181 × 74 × 40 cm

Artists' Biographies

Artists' Biographies

Artists' publications, unless a memoir, are not included in this section.

Shiva Ahmadi

Born 1975 in Tehran. Lives in the Bay Area and teaches at the University of California, Davis, California.

Education

2005 MFA Cranbrook Academy of Arts, Bloomfield Hills, Michigan
2003 Wayne State University, Detroit, Michigan
1998 BFA Azad University, Tehran

Solo Exhibitions

2016 *Spheres of Suspension*, Charles B. Wang Center, New York
2014 *Shiva Ahmadi: In Focus*, Asia Society Museum, New York
2013 *Apocalyptic Playland*, Leila Heller Gallery, New York
2012 *Throne*, College of Wooster Art Museum, Wooster, Ohio

Group Exhibitions

2016 *Global/Local: Six Artists from Iran, 1960–2015*, Grey Art Gallery, New York University, New York
 Fireflies in the Night Take Wing, Stavros Niarchos Foundation Cultural Center, Athens, Greece
2013 *Small Works Project*, Venice Biennale, Venice
2012 *The Fertile Crescent*, Institute for Women and Art, Rutgers University, Newark, New Jersey
2009 *Iran Inside Out*, Chelsea Art Museum, New York
2005 Portland Museum of Art Biennial, Portland, Maine

Bibliography

Alexander, Livia, "Tracing Tradition in a Survey of Six Iranian Artists", *Hyperallergic*, 18 March 2016.

Cotter, Holland, "The Personal, the Political, the Dead", *The New York Times*, 15 January 2016, pp 27, 33.

Daftari, Fereshteh, "Altered Miniatures: Shiva Ahmadi", *Canvas Magazine*, vol 7, no 2, March–April 2011, pp 176–185.

Genocchio, Benjamin, "A Dialogue Between Tradition and Innovation", *The New York Times*, 7 November 2008.

Mintz, Ally, "Shiva Ahmadi", *Global/Local: Six Artists from Iran, 1960–2015*, Lynn Gumpert ed, New York: Grey Art Gallery, New York University, 2016.

Muhammad, Sehba, "Shiva Ahmadi Animates Tales of Violence and Beauty", *Modern Painters*, 11 June 2014.

Morteza Ahmadvand

Born 1981 in Khorramabad, Iran. Lives and works in Tehran.

Education

2009 MA University of Tehran

Solo Exhibitions

2014 Etemad Gallery, Tehran
2011 Etemad Gallery, Tehran

Group Exhibitions

2014 *A Review of a Decade of Video Art in Iran*, Iranian Artists Forum, Tehran
2013 Etemad Gallery, Dubai
2013 *Kiarostami and Ahmadvand: Regards Persans*, Musée de la Chasse et de la Nature, Paris

Bibliography

Porter, Yves, "Au Pays du Simorgh", *Kiarostami and Ahmadvand: Regards Persans*, Claude D'Anthenaise ed, Paris: Musée de la Chasse et de la Nature, 2013.

Pottier, Marc, "Regards Persans", *Kiarostami and Ahmadvand: Regards Persan*, Claude D'Anthenaise ed, Paris: Musée de la Chasse et de la Nature, 2013.

Shirin Aliabadi

Born 1973 in Tehran. Lives and works in Tehran.

Education

Art and Art History, University of Paris

Solo Exhibitions

2012 *Girls Nights*, Farjam Collection, Dubai
2010 *Eye Love You*, The Third Line, Dubai

Group Exhibitions

2015 *Kitsch ou pas Kitsch?*, Institut des Cultures d'Islam, Paris
2014 *Art from Elsewhere*, Gallery of Modern Art, Glasgow, UK
2012 *The Other Half of Iran*, Sem Art Gallery, Monaco
2009 *Iran Inside Out*, Chelsea Art Museum, New York
2006 *Ethnic Marketing*, Artspace and Azad Gallery, Tehran
 Farhad Moshiri and Shirin Aliabadi: Images of the Middle East. Danish Center for Cultural Development, Copenhagen

Bibliography

Amirsadeghi, Hossein, ed, *Different Sames: New Perspectives in Contemporary Iranian Art*, London: Thames and Hudson in association with TransGlobe Publishing, 2009.

Debras, Berenice, "Exploring the Feminine: Shirin Aliabadi", *L'Agenda*, April 2010, pp 22–24.

Drucks, Achim, "The Subversive Potential of Hermès Scarves", *ArtMag by Deutsche Bank*, http://db-artmag.com/en/77/feature/the-subversive-potential-of-hermes-scarves-shirin-aliabadi-discl/.

Saad, Rhonda, "Empire and Orientalism", Empire and its Discontents, Amy Ingrid Schlegel ed, Medford, MA: Tufts University Art Gallery, 2008.

Afruz Amighi

Born 1974 in Tehran. Lives and works in New York.

Education

2007 MFA New York University
1997 BA Political Science, Barnard College at Columbia University, New York

Solo Exhibitions

2016 *Mangata*, Leila Heller Gallery, Dubai
2014 *Far From God*, Nicelle Beauchene Gallery, New York
2010 *Angels in Combat*, Isabelle van den Eynde Gallery, Dubai

Group Exhibitions

2016 *Wondrous Worlds: Art and Islam through Time and Place*, Newark Museum, Newark, New Jersey
The Language of Human consciousness, Athr Gallery, Jeddah, Saudi Arabia
2013 *Love Me, Love Me Not: Contemporary Art from Azerbaijan and its Neighbours*, Arsenale Nord, Venice; travelled to Heydar Aliyev Center, Baku, 2014
2012 *The Elephant in the Dark*, Devi Art Foundation, New Delhi
Doris Duke's Shangri-La, Museum of Arts and Design, New York (travelling exhibition)
Contemporary Iranian Art in the Permanent Collection, the Metropolitan Museum of Art, New York
2010 *Light of the Sufis: The Mystical Arts of Islam, Museum* of Fine Arts, Houston, Texas
2009 *Jameel Prize Exhibition*, Victoria and Albert Museum, London (winner of prize)

Bibliography

Akbarnia, Ladan, *Light of the Sufis: The Mystical Arts of Islam*, Ladan Akbarnia and Francesca Leoni eds, Houston: The Museum of Fine Arts, 2010, p 58.

Albury, Vanessa, "Afruz Amighi: Far from God", *Art Pulse Magazine*, vol 5, no 19, 2014, p 66.

Kalsi, Jyoti, "Reflections on Belonging and Displacement", *Gulf News*, 25 May 2016.

Proctor, Rebecca Anne, "Afruz Amighi: Utopian Towers", *Harper's Bazaar*, 22 June 2016, pp 110–113.

Wallace-Thompson, Anna, "The Allegory of the Cave", *Canvas Magazine*, vol 3, no 1, January 2011, pp 130–137.

Nazgol Ansarinia

Born 1979 in Tehran. Lives and works in Tehran.

Education

2003 MFA California College of the Arts, San Francisco, California
2001 BA, London College of Communication, UK

Solo Exhibitions

2016 *Paper Trail*, Raffaella Cortese Gallery, Milan
2015 *Surfaces and Solids*, Green Art Gallery, Dubai
2012 *Subtractions/Refractions*. Aun Gallery, Tehran
2012 *Reflections*, Daniela da Prato Gallery, Paris
2011 *Interior Renovations, Tehran, 2010*, Green Cardamom, London

Group Exhibitions

2016 11th Gwangju Biennale, Gwangju, South Korea
2015 *Dust*, Centre of Contemporary Art, Warsaw
2015 56th Venice Biennale, Iranian Pavilion, Venice

2013 *The Fascination of Persia*, Rietberg Museum, Zurich

Safar/Voyage: Contemporary Works by Arab, Iranian, and Turkish Artists, Museum of Anthropology at the University of British Columbia, Vancouver

2012 *The Elephant in the Dark*, Devi Art Foundation, New Delhi

2011 12th Istanbul Biennial, Istanbul

2010 *Tarjama/Translation*, Queens Museum of Art, New York (travelling exhibition)

2009 *Iran Inside Out*, Chelsea Art Museum, New York

Tarjama/Translation: Contemporary Art from the Middle East, Central Asia, and their Diaspora, Queens Museum of Art, Queens, New York (travelling exhibition)

Bibliography

Ahmadi, Leeza, Iftikhar Dadi, and Reem Fadda, *Tarjama/Translation: Contemporary Art from the Middle East, Central Asia, and their Diaspora*, Queens, New York: Queens Museum of Art, 2009.

Amirsadghi, Hossein, ed, *Different Sames: New Perspectives in Contemporary Iranian Art*, London: Thames and Hudson in association with TransGlobe, 2009, pp 74–77.

Daftari, Fereshteh, "Passport to Elsewhere", *Safar/ Voyage: Contemporary Works by Arab, Iranian, and Turkish Artists*, Daftari and Jill Baird eds, Vancouver, Toronto and Berkeley: Douglas and McIntyre; and Vancouver: Museum of Anthropology at the University of British Columbia, 2013.

Faiznia, Mazdak and Marco Meneguzzo, eds, *The Great Game*, Milan: Silvana Editoriale, 2015.

Fakhr, Leyla, "Rhyme and Reason: Nazgol Ansarinia", *Abraaj Capital Art Prize 2009*, Dubai: Abraaj Capital Art Prize, 2009.

Langer, Axel, ed, *The Fascination of Persia: The Persian-European Dialogue in Seventeenth-Century Art and Contemporary Art from Tehran*, Zurich: Museum Rietberg, 2013.

Nasar, Hammad, "How Things work: The Practice of Nazgol Ansarinia", *Tarjama/Translation: Contemporary Art from the Middle East, Central Asia, and their Diaspora*, Queens, New York and Ithaca, New York: Queens Museum of Art and Herbert F. Johnson Museum of Art, Cornell University, 2009, pp 28–29.

Pedrosa, Adriano, "Interview with Adriano Pedrosa", *Companion to the 12th Istanbul Biennial*, Istanbul: Istanbul Foundation for Culture and Arts and Yapi Kredi Publications, 2011, pp 100–103.

Mahmoud Bakhshi

Born 1977 in Tehran. Lives and works in Tehran.

Education

2001 BA Faculty of Fine Arts, University of Tehran

Solo Exhibitions

2015 *Mahmoud Bakhshi*, Etemad Gallery, Tehran

2014 *Talk Cloud*, Narrative Projects, London, and Yay Gallery, Baku

2014 *Talk Cloud*, Niavaran Cultural Center, Tehran

2012 *Hard Copy*, Art Gwangju, Gwangju

The Elephant in the Dark, Devi Art Foundation, New Delhi

2011 *Bah Man*, Galerie Thaddaeus Ropac, Paris

2010 *Mahmoud Bakhshi. The Engaged Artist: Influences of Graphics on Sculpture in the Middle Ages*, Magic of Persia, 2009 Contemporary Art Prize Winner, Saatchi Gallery, London

2007 Solo Show, Performance, XVA Gallery, Tehran

2006 *Mahmoud's Driving School*, Tehran Gallery, Tehran

2004 *Oh Abolfazl*, Bazaar Mosque and Golestan Gallery, Tehran

Group Exhibitions

2016 *Engage, Exchange*, Kunstruimtevan De Nederlandsche Bank, Amsterdam

2015 *The Great Game*, National Pavilion of Iran at 56th Venice Biennale, Venice

2014 *Recalling the Future: Post-Revolutionary Iranian Art*, Brunei Gallery, SOAS, University of London, UK
2013 *Love Me, Love Me Not: Contemporary Art from Azerbaijan and its Neighbours*, Arsenale Nord, Venice; Heydar Aliyev Center, Baku, 2014
2012 *Transformed Visions*, Tate Modern, London
2010 *Last Ride in a Red Hot Balloon*, 4th Auckland Triennial, Auckland
2009 *Iran Inside Out*, Chelsea Art Museum, New York
Raad O Bargh: 17 Artists from Iran, Galerie Thaddaeus Ropac, Paris
2008 *Iran: New Voices –Contemporary Iranian Film and Video Art*, Barbican Centre, London
Lion Under the Rainbow: Contemporary Art from Tehran, Art Athena, Athens
2006 *Iran.com: Iranian Art Today*, Museum für Neue Kunst, Freiburg

Bibliography

Amirsadeghi, Hossein, ed, *Different Sames: New Perspectives in Iranian Contemporary Art*, London: Thames and Hudson in association with TransGlobe, 2009, pp 210–211.

Daftari, Fereshteh, *City of Tales Updated*, London: Saatchi Gallery, 2009.

Fellrath, Till and Sam Bardaouil, eds, *Iran inside Out*, New York: Chelsea Art Museum, 2009.

Gavin, Francesca, *100 New Artists*, London: Laurence King Publishing, 2011.

Georgiou, Alexandros, ed, *Lion Under the Rainbow: Contemporary Art from Tehran*, Athens: D Art, 2008.

Grigor, Talinn, *Contemporary Iranian Art: From the Street to the Studio*, London: Reaktion Books, 2014.

Keshmirshekan, Hamid, *Contemporary Iranian Art: New Perspectives*, London: Saqi, 2013.

Mahlouji, Vali, *Raad O Bargh: 17 Artists from Iran*, Paris: Galerie Thaddaeus Ropac, Les Editions Jalou, 2009.

Nasser-Khadivi, Dina, *Love Me, Love Me Not: Contemporary Art from Azerbaijan and its Neighbours*, Venice: Arsenale Nord, 2013; Heydar Aliyev Center, Baku, 2014, pp 90–93.

Ali Banisadr

Born 1976 in Tehran. Lives and works in New York.

Education

2007 MFA New York Academy of Art
2005 BFA School of Visual Arts, New York

Solo Exhibitions

2015 *At Once*, Blain Southern, London
2014 *Motherboard*, Sperone Westwater, New York
2012 *We Haven't Landed on Earth Yet*, Galerie Thaddaeus Ropac, Salzburg
2008 *Ali Banisadr: Paintings*, Leslie Tonkonow Artworks + Projects, New York

Group Exhibitions

2014 *Eurasia: A View on Painting*, Thaddaeus Ropac, Paris Pantin
2013 *Love Me, Love Me Not: Contemporary Art from Azerbaijan and its Neighbours*, 55th Venice Biennale, Venice; travelled to Heydar Aliyev Center, Baku, 2014
Safar/Voyage: Contemporary Works by Arab, Iranian, and Turkish Artists, Museum of Anthropology at University of British Columbia, Vancouver
2012 *Contemporary Iranian Art from the Permanent Collection*, The Metropolitan Museum of Art, New York
2011 *East Ex East*, Brand New Gallery, Milan, Italy
2010 *Hareng Saur: Ensor and Contemporary Art*, Stedelijk Museum voor Actuele Kunst, Ghent

Bibliography

Daftari, Fereshteh, "Voices of Evil: A Common World Order", *Ali Banisadr*, Paris: Galerie Thaddaeus Ropac, 2010.

Daftari, Fereshteh, "Passport to Elsewhere", *Safar/Voyage: Contemporary Works by Arab, Iranian, and Turkish Artists*, Daftari and Jill Baird eds, Vancouver, Toronto, Berkeley: Douglas and McIntyre; Vancouver: Museum of Anthropology at University of British Columbia, 2013.

Deitch, Jeffrey, *Sound of Painting*, New York: Sperone Westwater, 2014.

Ekhtiar, Maryam and G. Lindquist, *We Haven't Landed on Earth Yet*, Salzburg: Galerie Thaddaeus Ropac, 2012.

Farzin, Media, "Profile: Clamour and Colour—Ali Banisadr", *Canvas Magazine*, September 2011, pp 134 –141.

Nasser-Khadivi, ed, *Love Me, Love Me Not: Contemporary Art from Azerbaijan and its Neighbours*, Venice: 55th Venice Biennale, 2013.

Southern Graham, ed, *Ali Banisadr: One Hundred and Twenty Five Paintings*, with a text by Robert Hobbs and a conversation with Boris Groys, London: Blain Southern, 2015.

Alireza Dayani

Born 1982 in Tehran. Lives and works in Tehran.

Education

2004 BS Psychology, Azad University, Tehran

Solo Exhibitions

2013 *Alireza Dayani*, Mah Art Gallery, Tehran
2011 *Alireza Dayani*, Mah Art Gallery, Tehran
2006 Dey Gallery, Tehran
2004 *Still Life Paintings*, Golestan Gallery, Tehran

Group Exhibitions

2016 *50 Artists*, Mah Art Gallery, Tehran
2015 *Onirismos*, Visiones e Fantasias, Amon-Ra Gallery of the Visionary and Fantastic Arts, Monterrey, Mexico
2012 *The Elephant in the Dark*, Devi Art Foundation, New Delhi
2011 Art Dubai, UAE
2009 *Iran Inside Out*, Chelsea Art Museum, New York
 Selseleh Zelzeleh, LTMH Gallery, New York
2008 *Selection of Works by 50 Artists*, Mah Art Gallery, Tehran
2006 *Ashoura*, Emam Ali Museum, Tehran

Bibliography

Amirsaghi, Hossein, ed, *Different Sames: New Perspectives on Iranian Contemporary Art*, London: Thames and Hudson in association with TransGlobe Publishing, 2009, p 111.

Fellrath, Till and Sam Bardaouil, eds, *Iran Inside Out: Influences of Homeland and Diaspora on the Artistic Language of Contemporary Iranian Artists*, New York: Chelsea Art Museum, 2009, pp 40–41.

Mohammed Ehsai

Born 1939 in Ghazvin. Lives and works in Vancouver.

Education

Faculty of Fine Art, Tehran University

Solo Exhibitions

2002 *The Alphabet of Eternity*, Ziba Gallery, Vancouver
1991 Oulu Gallery, Finland

1976 Galerie Cyrus, Paris
1974 Iran-America Society, Tehran
1973 Seyhoun Gallery, Tehran

Group Exhibitions

2015 *The Great Game*, Venice Biennale, Venice
2013 *Iran Modern*, Asia Society Museum, New York
2011 *The Art of Writing*, ArtForum in der Kurhaus Kolonnade, Wiesbaden
2007 *Dance of Pen and Ink: Contemporary Art from the Middle East*, Moscow State Museum (travelling exhibition)
2006 *Word Into Art: Artists of the Modern Middle East*, The British Museum, London
2004 *Inheritance*, Leighton House Museum, London
2001 *Iranian Contemporary Art*, Barbican Centre, London
1976 *Modern Iranian Art*, International Art Fair, Basel

Bibliography

Amirsadeghi, Hossein, ed, *Different Sames: New Perspectives in Contemporary Iranian Art*, London: Thames and Hudson in association with TransGlobe Publishing, 2009, pp 116–117.

Eigner, Saeb, *Art of the Middle East: Modern and Contemporary Art of the Arab World and Iran*, London and New York: Merrell, 2010.

Fouladvand, Hengameh, "Modernist Explorations in Calligraphic Form and Content: Mohammad Ehsai", *Art Tomorrow*, issue 6, autumn 2011, pp 163–169.

Issa, Rose, Ruyin Pakbaz, and Daryush Shayegan, *Iranian Contemporary Art*, London: Barbican Art Booth-Clibborn Editions, 2001.

Krohl, Heinz, *The Art of Writing: Contemporary Art from Three Cultures*, Heidelberg: Kehrer, 2011.

Keshmirshekan, Hamid, *Contemporary Iranian Art: New Perspectives*, London: Saqi Books, 2013.

Modern Iranian Art: The International Art Fair 7'76, Basel, Switzerland, Tehran: Offset Press, 1976.

Porter, Venetia, *Word Into Art: Artists of the Modern Middle East*, London: The British Museum, 2006.

Monir Farmanfarmaian

Born 1924 in Qazvin. Lives and works in Tehran.

Education

Faculty of Fine Arts, Tehran University
1949 Parsons School of Design
1949 Art Students League

Solo Exhibitions

2014 *Monir Shahroudy Farmanfarmaian. Infinite Possibility: Mirror Works and Drawings, 1974–2014*, Fundaçao de Serralves, Porto; travelled to The Guggenheim Museum, New York, 2015
2013 *Monir Farmanfarmaian 2004–2013*, The Third Line, Dubai
2008 *Geometry of Hope*, Leighton House Museum, London
2006 *Variations on the Hexagon*, Victoria and Albert Museum, London
A Review of the Artwork of Monir Shahroudy Farmanfarmaian, Niavaran Cultural Center, Tehran
1977 *Monir Shahroudy Farmanfarmaian*, Galerie Denise René, Paris and New York
1973 *Monir Shahroudy Farmanfarmaian*, Iran-America Society, Tehran

Group Exhibitions

2014 *Artevida*, Casa França-Brasil, Rio de Janeiro
2013 *Transparencies: Contemporary Art and A History of Glass*, Des Moines Art Center, Des Moines
Sharjah Biennial 11, Sharjah Foundation, UAE
Trade Routes, Hauser and Wirth, London

Iran Modern, Asia Society Museum, New York
2010 *The Future of Tradition—The Tradition of Future*, Haus der Kunst, Munich
2009 *East-West Divan: Contemporary Art from Afghanistan, Iran and Pakistan*, 53rd Venice Biennale, Venice
 APT: 6 Asia Pacific Triennial of Contemporary Art, Queensland Art Gallery
2002 *Between Word and Image*, Grey Art Gallery, New York
1968 *Modern Persian Painting*, Center for Iranian Studies, Columbia University, New York
1966 33rd Venice Biennale, Iranian Pavilion, Venice
1958 First Tehran Biennial, Golestan Palace, Tehran

Bibliography

Cotter, Suzanne, ed, *Monir Shahroudy Farmanfarmaian. Infinite Possibility: Mirror Works and Drawings, 1974–2014*, Porto: Serralves, 2014.

Daftari, Fereshteh, "Redefining Modernism: Pluralist Art Before the Revolution", *Iran Modern*, Fereshteh Daftari and Layla Diba eds, New York: Asia Society Museum; New Haven and London: Yale University Press, 2013.

Farmanfarmaian, Monir Shahroudy and Zara Houshmand, *A Mirror Garden: A Memoir*, New York: Anchor Books, 2007.

Issa, Rose, ed, *Monir Shahroudy Farmanfarmaian: Heartaches*, Tehran: Nazar Publishers: Nazar Research and Cultural Institute, 2008.

Issa, Rose, ed, *Monir Shahroudy Farmanfarmaian: Mosaics of Mirrors*, Tehran: Nazar Publishers, Nazar Research and Cultural Institute, 2006.

Obrist, Hans Ulrich and Karen Marta, eds, *Monir Shahroudy Farmanfarmaian: Cosmic Geometry*, Bolognia: Damiani Editore; and Dubai: The Third Line, 2011.

Parastou Forouhar

Born 1962 in Tehran. Lives and works in Germany.

Education

1990 BA Tehran University
1994 MA College of Art, Offenbach, Germany

Solo Exhibitions

2011 *Written Room*, Fondazione Merz, Turin
2010 *He Kills Me, He Kills Me Not*, Leighton House Museum, London
2009 *Parastou Forouhar*, Gallery Karin Sachs, Munich
2003 *Thousand and One Day*, National Gallery at Hamburger Bahnhof, Berlin

Group Exhibitions

2013 *The Fascination of Persia: The Persian-European Dialogue in Seventeenth-Century Art and Contemporary Art from Tehran*, Rietberg Museum, Zurich
2012 *The Fertile Crescent: Gender, Art and Society*, Princeton University Art Museum, New Jersey
2009 *Iran Inside Out: Influences of Homeland and Diaspora on the Artistic Language of Contemporary Artists*, Chelsea Art Museum, New York
 The Promise of Loss: A Contemporary Index of Iran, Hilger Brot Kunsthalle, Vienna
2007 *Global Feminisms: New Directions in Contemporary Art*, Brooklyn Museum, New York

Bibliography

Brodsky, Judith K. and Ferris Olin, eds, *The Fertile Crescent: Gender, Art, and Society*, New Brunswick, New Jersey: The Rutgers University Institute for Women and Art; and New York: DAP, 2012.

Issa, Rose, *Iranian Photography Now*, Ostfildern: Hatje Cantz, 2008.

Langer, Axel, ed, *The Fascination of Persia: The Persian-European Dialogue in Seventeenth-Century Art and Contemporary Art from Tehran*, Zurich: Museum Rietberg, 2013.

Merali, Shaheen, *The Promise of Loss: A Contemporary Index of Iran*, Vienna: Hilger Brot Kunsthalle, 2009.

Reilly, Maura and Linda Nochlin, eds, *Global Feminisms: New Directions in Contemporary Art*, London and New York: Merrell, 2007.

Wintsch, Susann, "Eine Strategie der Vieldeutigkeit", *Beaux Arts Magazine*, issue 297, March 2009, pp 86–91.

Shadi Ghadirian

Born 1974 in Tehran. Lives and works in Tehran.

Education

1998 BA Azad University, Tehran

Solo Exhibitions

2007 B21 Gallery, Dubai

Group Exhibitions

2013 *She Who Tells A Story: Women Photographers from Iran and the Arab World*, Museum of Fine Arts, Boston, Massachusetts
2012 *The Fertile Crescent: Gender, Art, and Society*, Bernstein Gallery, Woodrow Wilson School of Public and International Affairs, Princeton University, New Jersey
2009 *Unveiled: New Art from the Middle East*, Saatchi Gallery, London
2008 Singapore Biennial
30 Years of Solitude, Asia House, London
2003 Sharjah Biennial, Sharjah
2001 *Iranian Contemporary Art*, Barbican Centre, London

Bibliography

Brodsky, Judith K. and Ferris Olin, eds, *The Fertile Crescent: Gender, Art, and Society*, New Brunswick, New Jersey: The Rutgers University Institute for Women and Art; and New York: DAP, 2012.

Gresh, Kristen, ed, *She Who Tells a Story: Women Photographers from Iran and the Arab World*, Boston: Museum of Fine Arts, 2013.

Issa, Rose, ed, *Shadi Ghadirian: Iranian Photographer*, London: Saqi Books, 2008.

Issa, Rose, Ruyin Pakbaz, and Daryush Shayegan, *Iranian Contemporary Art*, London: Barbican Art Booth-Clibborn Editions, 2001.

Javaherian, Faryar, ed, *30 Years of Solitude*, London: Iran Heritage Foundation and Asia House, 2008.

Muller, Nat, Lindsey Moore, T.J. Demos, and Suzanne Cotter, *Contemporary Art in the Middle East*, London: Black Dog Publishing, 2009.

Rokni Haerizadeh

Born 1978 in Tehran. Lives and works in Dubai.

Education

MA Tehran University

Solo Exhibitions

2016 *Rokni Haerizadeh: Reign of Winter*, Yallay Gallery, Hong Kong
2015 *The Birthday Party*, collaborative exhibition with Ramin Haerizadeh and Hesam Rahmanian, The Institute of Contemporary Art, Boston, Massachusetts
Those Who Love Spiders and Let Them Sleep in their Hair, Den Frie Centre of Contemporary Art, Copenhagen
2014 *The Exquisite Corpse Shall Drink the New Wine*, collaborative exhibition with Ramin Haerizadeh and

Hesam Rahmanian, Gallery Isabelle van den Eynde, Dubai
2008 *Tehran 206*, Ave Gallery, Tehran
2004 *Paintings by Rokni Haerizadeh*, The Third Line, Dubai

Group Exhibitions

2016 *But A Storm Is Blowing form Paradise: Contemporary Art of the Middle East
and North Africa*, The Guggenheim Museum, New York
2015 8th Asia Pacific Triennial, Brisbane
2014 *Here and Elsewhere*, New Museum, New York
2013 *Carnegie International 2013*, Pittsburgh
2011 Sharjah Biennial, Sharjah
2009 *Unveiled: New Art from the Middle East*, Saatchi Gallery, London
2001 Golestan Gallery, Tehran

Bibliography

Azimi, Negar, *Rokni Haerizadeh: Fictionville*, London: Koenig Books, 2014.

Hughes, Isabella E., "Where I Work: Ramin Haerizadeh, Rokni Haerizadeh and Hesam Rahmanian", *ArtAsiaPacific,* issue 89, July–August 2014.

Larmon, Anne Godfrey, "Ramin Haerizadeh, Rokni Haerizadeh, and Hesam Rahmanian", *ArtForum,* vol 54, no 7, March 2016, p 280.

Khosrow Hassanzadeh

Born 1963 in Tehran. Lives and works in Tehran and London.

Education

1999 Persian Literature, Azad University, Tehran
1996–1998 Private art courses with Aydin Aghdashloo
1991 Faculty of Painting, Mojtama-e Honar University, Tehran

Solo Exhibitions

2012 *Khosrow Hassanzadeh, Haft Khan: The Seven Labors of Rostam*, Leila Heller Gallery, New York
2009 *Takhti (Ready to Order series)*, The British Museum, London
2008 *Ready to Order*, B21 Gallery, Dubai
2006 *Khosrow Hassanzadeh*, B21 Gallery, Dubai
2005 *Works of Khosrow Hassanzadeh*, Arta Gallery, Vancouver
Terrorist, Silk Road Gallery, Tehran
1999 *Life, War, and Art: Paintings of Khosrow Hassanzadeh*, Diorama Arts Centre, London

Group Exhibitions

2016 *Kitsch ou pas kitsch?,* Institut des Cultures d'Islam, Paris
2012 *The Elephant in the Dark*, Devi Art Foundation, New Delhi
2009 *Iran: Inside Out*, Chelsea Art Museum, New York
2006 *Word Into Art*, The British Museum, London
2004 *Far Near Distance: Contemporary Positions of Iranian Artists*, Haus der Kulturen der Welt, Berlin
2002 *Second Exhibition of Iranian conceptual Art*, Tehran Museum of Contemporary Art
2001 *Iranian Contemporary Art*, Barbican Centre, London

Bibliography

Issa, Rose, Ruyin Pakbaz, and Daryush Shayegan, *Iranian Contemporary Art*, London: Barbican Art Booth-Clibborn Editions, 2001.

Porter, Venetia, *Word Into Art: Artists of the Modern Middle East*, London: The British Museum Press, 2006.

Shatanawi, Mirjam, ed, *Tehran Studio Works: The Art of Khosrow Hassanzadeh*, London: Saqi Books, 2007.

Shirazeh Houshiary

Born 1955 in Tehran. Lives and works in London.

Education

1980 Cardiff College of Art, Wales
1979 Chelsea School of Art, London

Solo Exhibitions

2016 *Shirazeh Houshiary*, Singapore Tyler Print Institute, Singapore
2015 *Smell of First Snow*, Lisson Gallery, London
 Shirazeh Houshiary, Lehmann Maupin, Hong Kong
2013 *Breath*, Torre di Porta Nuova, collateral event of the 55th Venice Biennale, Venice
2011 *Altar*, Saint Martin-in-the-Fields, London
2004 *Breath*, Battery Park City, New York, Commissioned by Creative Time
1999 *Shirazeh Houshiary: Recent Works*, Lehmann Maupin Gallery, New York
1994 *The Sense of Unity*, Lisson Gallery, London
1993 *Dancing Around My Ghost*, Camden Arts Centre, London

Group Exhibitions

2015 *Phantom Bodies: The Human Aura in Art*, Frist Center for the Visual Arts, Nashville, Tennessee
2014 *Reductive Minimalism: Women Artists in Dialogue, 1960–2014*, University of Michigan Museum of
 Art, Ann Arbor, Michigan
2013 *Pattern: Follow the Rules*, Eli and Edythe Broad Art Museum, East Lansing, Michigan
 Glasstress: White Light/White Heat, Palazzo Cavallo Franchetti, collateral event of the 55th Venice
 Biennale, Venice
2012 *Arsenale 2012*, Kiev Biennale, Kiev, Ukraine
2010 17th Biennale of Sydney, Sydney
2006 *Without Boundary: Seventeen Ways of Looking*, Museum of Modern Art, New York
1996 São Paulo Biennial, São Paulo
1995 *Isthmus*, Le Magasin, Centre national d'art contemporain, Grenoble, France (travelling exhibition)
1993 Venice Biennale, Venice
1989 *Magiciens de la terre*, Musée national d'art modern, Centre national d'art et de Culture Georges
 Pompidou, Paris
1982 *Aperto '82*, 40th Venice Biennale, Venice

Bibliography

Coppola, Regina, *Shirazeh Houshiary: Turning around the Center*, Amherst: University Gallery,
University of Massachusetts; Toronto: Art Gallery of York University, 1993.

Daftari, Fereshteh, "Beyond Islamic Roots – Beyond Modernism", *RES,* issue 43, spring 2003,
pp 175–186.

———, "Shirazeh Houshiary/Pip Horne", *Skulptur Biennale Münsterland 2003*, Alice Koegel ed,
Freiburg im Breisgau: modo Verlag, 2003, pp 70–73, 142–143.

———, *Without Boundary: Seventeen Ways of Looking*, New York: The Museum of Modern Art, 2006.

Hilty, Greg, Francis Gooding, and Daid Toop, *No Boundary Condition*, London: Lisson Gallery, 2011.

Littman, Klaus, *Skultur*, Basel: Christoph Merian Verlag, 2000.

Logsdail, Nicholas, ed, *Smell of First Snow*, London: Lisson Gallery, 2015.

Rose, Andrea, ed, *Isthmus: Shirazeh Houshiary*, Grenoble: Magasin—Centre national d'art
contemporain de Grenoble; Munich: Museum Villa Stuck; Maastricht: Bonnefantenmuseum;
London: The British Council, 1995.

Y.Z. Kami

Born 1956 in Tehran. Lives and works in New York.

Education

1982 Conservatoire Libre du Cinéma Français, Paris
1981 Université Paris-Sorbonne, Paris
1975 University of California, Berkeley

Solo Exhibitions

2016 *Y.Z. Kami: Endless Prayers*, Los Angeles County Museum
2016 *Y.Z. Kami: White Domes*, Leila Heller Gallery, Dubai
2015 *Y.Z. Kami,* Gagosian Gallery, London
2014 *Y.Z. Kami: Paintings*, Gagosian Gallery, New York
2010 *Y.Z. Kami: Beyond Silence*, National Museum of Contemporary Art, Athens
2009 *Y.Z. Kami: Endless Prayers*, Parasol Unit, London
2008 *Y.Z. Kami*, Gagosian Gallery, New York
2003 *Portraits by Y.Z. Kami*, Herbert F. Johnson Museum of Art, Cornell University, Ithaca, New York
2001 Deitch Projects, New York
1996 Holly Solomon Gallery, New York
1992 Barbara Toll Fine Arts, New York

Group Exhibitions

2013 *Safar/Voyage: Contemporary Works by Arab, Iranian, Turkish Artists*, The Museum of Anthropology, University of British Columbia, Vancouver
2011 *The Mask and the Mirror*, Leila Heller Gallery, New York
2009 *A Certain State of the World? Works from the François Pinault Foundation*, Garage Museum for Contemporary Art, Moscow
2007 *All the More Real: Portrayals of Intimacy and Empathy*, The Parrish Art Museum, New York
2006 *Without Boundary: Seventeen Ways of Looking*, The Museum of Modern Art, New York
2005 9th International Istanbul Biennial, Istanbul
2004 *Beyond East and West: Seven Transnational Artists*, Krannert Art Museum, Champaign, Illinois
1997 *Projects 59: Architecture as Metaphor*, The Museum of Modern Art, New York

Bibliography

Daftari, Fereshteh, ed, *Without Boundary: Seventeen Ways of Looking*, New York: The Museum of Modern Art, 2006.

—"Passport to Elsewhere", *Safar/Voyage: Contemporary Works by Arab*, Iranian, *and Turkish Artists*, Daftari and Jill Baird eds, Vancouver, Toronto, Berkeley: Douglas and McIntyre; Vancouver: Museum of Anthropology at University of British Columbia, 2013.

Kafetsi, Anna, ed, *Y.Z. Kami: Beyond Silence*, Athens: National Museum of Contemporary Art, 2010.

Madoff, Steven Henry, *Y.Z. Kami*, New York: Gagosian Gallery, 2008.

Storr, Robert, *Y.Z. Kami: Paintings*, New York: Gagosian Gallery, 2014.

De Weck Ardalan, Ziba, ed, *Y.Z. Kami: Endless Prayers*, London: Parasol Unit/Koenig Books, 2008.

Abbas Kiarostami 1940–2016

Lived and worked in Tehran.

Education

1958 Tehran University

Solo Exhibitions

2015 *Doors Without Keys*, Aga Khan Museum, Toronto
2012 *Abbas Kiarostami: Images, Still and Moving*, Kunstsammlungen der Ruhr-Universität, Bochum
(travelling exhibition)
2008 *Abbas Kiarostami,* Santa Maria della Scala, Siena
Abbas Kiarostami et Lynette Wallworth, Musée des Tapisseries, Aix-en-Provence
2007 *Abbas Kiarostami: Image Maker*, The Museum of Modern Art and PS1, New York
2006 *Abbas Kiarostami*, Beijing Art Museum, Beijing (travelling exhibition)
Snowscapes and Roadscapes, Akbank Art Gallery, Istanbul
2005 *Kiarostami's Forest Without Leaves*, Victoria and Albert Museum, London
2003 Museo del cinema, Turin

Group Exhibitions

2007 *Erice—Kiarostami: Correspondences*, Centre Pompidou, Paris
2004 *Gardens of Iran: Ancient Wisdom, New Visions*, Tehran Museum of Contemporary Art, Tehran
2004 39 Mostra Internacional de Cinema, Fundaçao Armando Álvarez Penteado, São Paulo
Far Near Distance: Contemporary Positions of Iranian Artists, Haus der Kulturen der Welt, Berlin
Photo Biennial, House of Photography, Moscow
2001 *Regards Persans*, Espace Electra, Paris
49th Venice Biennale, Venice

Bibliography

Akay, Ali, and Levent Çalikoglu, *Snowscapes and Roadscapes: A Photographic Series by Abbas Kiarostami*, Istanbul: Akbank Sanat, 2006.

Berswordt-Wallrabe, Silke, ed, *Abbas Kiarostami: Images, Still and Moving*, Ostfildern: Hatje Cantz, 2012.

Ishaghpour, Youssef, *Kiarostami: le réel, face et pile*, Belval: Circé, 2007.

Kiarostami, Abbas, *Snow White: Photo Collection, 1978–2004*, Tehran: Nazar Art Publications, 2005.

Petite Bibliothèque des Cahiers du Cinéma, ed, *Abbas Kiarostami: textes, entretiens, Filmographie Complète*, Paris: Cahiers du cinema, 2008; 1st ed 1997.

Shams, Sussan, *Le cinéma d'Abbas Kiarostami: un voyage vers l'orient mystique*, Paris: Harmattan, 2011.

Farhad Moshiri

Born 1963 in Shiraz, Iran. Lives and works in Tehran and Paris.

Education

1984 Fine Arts, California Institute of the Arts, Valencia

Solo Exhibitions

2014 *Float*, Galerie Perrotin, New York
My Flower, Hyundai Gallery, Seoul
2013 *Farhad Moshiri*, Galerie Rodolphe Janssen, Brussels
2012 Galerie Emmanuel Perrotin, Paris
2011 The Third Line, Dubai
2010 *Nothing Serious*, Galerie Thaddaeus Ropac, Salzburg

Group Exhibitions

2015 *Heaven and Hell. From Magic Carpets to Drones*, Boghossian Foundation, Villa Empain, Brussels
2014 *One Way: Peter Marino*, Bass Museum of Art, Miami, Florida
2013 *Love Me, Love Me Not: Contemporary Art from Azerbaijan and its Neighbours*, 55th Venice Biennale,
Venice; travelled to Heydar Aliyev Center, Baku, 2014
Safar/Voyage: Contemporary Works by Arab, Iranian, and Turkish Artists, Museum of Anthropology at

University of British Columbia, Vancouver
2012 *ART and PRESS*, Martin-Gropius-Bau, Berlin
2011 *The World Belongs to You*, Palazzo Grassi, Venice
2010 *Hope!*, Palais des Arts et du Festival de Dinard, France
2009 *Iran Inside Out*, Chelsea Museum, New York
Tarjama/Translation: Contemporary Art from the Middle East, Central Asia, and their Diaspora, Queens Museum of Art, Queens, New York (travelling exhibition)

Bibliography

Ahmadi, Leeza, Iftikhar Dadi, and Reem Fadda, *Tarjama/Translation: Contemporary Art from the Middle East, Central Asia, and their Diaspora*, Queens: Queens Museum of Art, 2009.

Daftari, Fereshteh, "Passport to Elsewhere", *Safar/Voyage: Contemporary Works by Arab, Iranian, and Turkish Artists*, Daftari and Jill Baird eds, Vancouver, Toronto, Berkeley: Douglas and McIntyre; Vancouver: Museum of Anthropology at University of British Columbia, 2013.

Hager, Martin, and Shahin Merali, eds, *Far Near Distance: Contemporary Positions of Iranian Artists*, with an essay by Rose Issa, Berlin: Haus der Kulturen der Welt, 2004.

Nasser-Khadivi, Dina, ed, *Farhad Moshiri*, Milan: Skira, 2016.

Sagharchi, Nima, "Farhad Moshiri: I Can't Get No Satisfaction", *Harper's Bazaar Art Arabia*, September–October 2014, pp 79–85.

Wick, Oliver, and Jérôme Sans, *Farhad Moshiri*, Brussels: Rodolphe Janssen; Dubai: The Third Line; Paris: Perrotin; Paris and Salzburg: Thaddaeus Ropac, 2010.

Timo Nasseri

Born 1972 in Berlin. Lives and works in Berlin.

Education

1997 Photography, Lette-Verein, Berlin

Solo Exhibitions

2016 *Lightmap*, AK, Vienna, Austria
2015 *The More Beneath My Feet the Skies I see*, Sfeir-Semler Gallery, Hamburg
Nine Firmaments, Schleicher/Lange, Berlin
2013 *Core*, Schleicher/Lange, Berlin
2012 *O Time thy Pyramids*, Galerie Sfeir-Semler, Hamburg
2009 *One of Six*, Kunstverein, Arnsberg

Group Exhibitions

2016 *A World View: The Tim Fairfax Gift*, Queensland Art Gallery, Gallery of Modern Art, Brisbane
Mass Individualism, Ab Anbar Gallery, Tehran
2015 *Triplicity*, Athr Gallery, Jeddah
2014 *Weights and Measures*, Galerie Lahumière, Paris
2013 *Dynamo: Space and Vision in Art from Today Back to 1913*, Grand Palais, Paris
2012 *Sculpture Is Everything*, Queensland Art Gallery and Gallery of Modern Art, Brisbane
2011 *Abraaj Art Prize*, Dubai

Bibliography

Allsop, Laura, "An Architecture of Apprehension: Timo Nasseri in conversation with Laura Allsop", *Ibraaz*, issue 3, 27 September 2012, www.Ibraaz.org.

Amirsadeghi, Hossein, ed, *Different Sames: New Perspectives in Contemporary Iranian Art*, London: Thames and Hudson in association with TransGlobe Publishing, 2009, pp 228–229.

Lemoine, Serge, *Dynamo: Un Siècle de lumière et de movement dans l'art, 1913–2013*, Paris: Réunion des Museées Nationaux, 2013.

A World View: The Tim Fairfax Gift, Brisbane: Queensland Art Gallery, 2016.

Zaferani, Azadeh, *Mass Individualism: A Form of Multitude*, Tehran: Ab Anbar, 2016.

Shirin Neshat

Born 1957 in Qazvin, Iran. Lives and works in New York.

Education

1982 MFA University of California, Berkeley

Solo Exhibitions

2015 *Shirin Neshat: Facing History*, Hirshhorn Museum and Sculpture Garden, Washington DC
2014 *Shirin Neshat: Our House is on Fire*, Rauschenberg Foundation Project Space, New York
2012 *Shirin Neshat: The Book of Kings*, Gladstone Gallery, New York
2008 *Shirin Neshat: Women Without Men*, Aros Aarhus Kunstmuseum, Aarhus, Denmark; Faurschou
 Foundation, Beijing
 Shirin Neshat, National Gallery of Iceland, Reykjavik
2005 *Shirin Neshat*, Hamburger Bahnhof für Gegenwart, Berlin
2002 *Shirin Neshat*, Castello di Rivoli, Museo d'Arte Contemporanea, Turin
2000 *Shirin Neshat*, Serpentine Gallery, London
1997 *Shirin Neshat: Women of Allah*, Artspeak Gallery, Vancouver
1996 *Shirin Neshat: Women of Allah*, Lucio Amelio Gallery, Naples
1993 *Unveiling*, Franklin Furnace, New York

Group Exhibitions

2012 *The Fertile Crescent: Gender, Art and Society*, Institute for Women and Art, Rutgers University, New
 Brunswick, New Jersey; and Princeton University Art Museum, Princeton, New Jersey
2009 *Iran Inside Out: Influences of Homeland and Diaspora on the Artistic Language of Contemporary Artists*,
 Chelsea Art Museum, New York
2006 *Without Boundary: Seventeen Ways of Looking*, The Museum of Modern Art, New York
2004 *Far Near Distance: Contemporary Positions of Iranian Artists*, Haus der Kulturen der Welt, Berlin
2002 Documenta, Kassel
1999 *Projects 70: Banners I – Shirin Neshat, Simon Patterson, and Xu Bing*, The Museum of Modern Art,
 New York
 48th Venice Biennale, Venice (winner of Golden Lion prize)
1995 Istanbul Biennial, Istanbul
1992 *Fever*, Exit Art, New York

Bibliography

Bonami, Francesco, Hamid Dabashi, and Octavio Zaya, *Shirin Neshat: Women of Allah*, Turin:
Marco Noire, 1997.

Chiu, Melissa, and Melissa Ho, eds, *Shirin Neshat: Facing History*, Washington, DC: Hirshhorn
Museum and Sculpture Garden, 2015 (*see this publication for extensive bibliography*).

Danto, Arthur C., and Marina Abramovic, Shirin Neshat, New York: Rizzoli, 2010.

Hart, Rebecca, Sussan Babaie, and Nancy Princenthal, *Games of Desire*, Detroit: Detroit Institute of
Arts, 2013.

Milani, Farzaneh, *Shirin Neshat*, Milan: Charta, 2001.

Shahpour Pouyan

Born in 1977 in Isfahan. Lives and works in Tehran and New York.

Education

2012 MFA Pratt Institute, New York

2007 MFA Tehran University, Tehran

Solo Exhibitions

2014 *Shahpour Pouyan: PTSD*, Lawrie Shabibi, Dubai
2011 *Full Metal Jacket*, Lawrie Shabibi, Dubai
2010 *The Hooves, Sixty Six Art Gallery*, Tehran
2009 XVA Gallery, Bastakia
2008 *Towers*, Ave Gallery, Tehran

Group Exhibitions

2016 *Home Land Security*, Fort Winfield Scott, San Francisco
 Yinchuan Biennale, Museum of Contemporary Art, Yinchuan, China
 Global/Local: Six Artists from Iran, 1960–2015, Grey Art Gallery, New York University
2013 *Art International*, Halic Convention Centre, Istanbul
 Mykonos Biennale, Mykonos
 Chambres à part VII: Dark to Light, Tower of London, London

Bibliography

Cotter, Holland, "The Personal, the Political, the Dead", *The New York Times*, 15 January 2016, pp 27, 33.

Lorch, Danna, "A Scientist and a Philosopher: An Interview with Shahpour Pouyan at Lawrie Shabibi", *Danna Writes: Art and Pop Culture from the Middle East* (blog), 2 July 2013.

Malas, Khaled, "Shahpour Pouyan", *Global/Local: Six Artists from Iran, 1960–2015*, Lynn Gumpert ed, Grey Art Gallery, New York University, New York, pp 88–97.

Shahpour Pouyan: Full Metal Jacket, Dubai: Lawrie Shabibi, 2011.

Vali, Murtaza, "From Phallus to Part-Object, *Shahpour Pouyan: PTSD*", Dubai: Lawrie Shabibi, 2014.

Hamed Sahihi

Born 1980 in Tehran, Iran. Lives and works in Tehran.

Education

2005 MA Art University of Tehran

Solo Exhibitions

2015 *Yazesh*, Azad Gallery, Tehran
2013 *Headline*, Azad Gallery, Tehran
2010 *White Box*, Mohsen Gallery, Tehran
 But in your head baby, I'm afraid you don't know where it is, Azad Gallery, Tehran

Group Exhibitions

2013 *The Fascination of Persia: The Persian-European Dialogue in Seventeenth-Century Art and Contemporary Art from Tehran*, Rietberg Museum, Zurich, Switzerland
2013 *Safar/Voyage: Contemporary Works by Arab, Iranian, and Turkish Artists*, The Museum of Anthropology (MOA) at the University of British Columbia, Vancouver
2011 *Big Lie*, Mohsen Art Gallery, Tehran
2010 *Tehran to London: New Painting from Iran*, Jill George Gallery, London

Bibliography

Amirsadeghi, Hossein, ed, *Different Sames: New Perspectives in Contemporary Iranian Art*, London: Thames and Hudson in association with TransGlobe Publishing, 2009, pp 240–241.

Daftari, Fereshteh, "Passport to Elsewhere", *Safar Voyage: Contemporary Works by Arab, Iranian, and Turkish Artists*, Daftari and Jill Baird eds, Vancouver, Toronto, Berkeley: Douglas and McIntyre and

Museum of Anthropology at the University of British Columbia, 2013.

Kamrani, Behnam, "Dreaming on Canvas", *Art Tomorrow,* issue 1, spring 2010, pp 124–128.

Langer, Axel, ed, *The Fascination of Persia: The Persian-European Dialogue in Seventeenth-Century Art and Contemporary Art from Tehran,* Zurich: Museum Rietberg, 2013.

Mojabi, Javad, "Sahihi: Symbolist of a Unified World", *Tandis* 143, February 2009, p 9.

Sharaf-Jahan, Rozita, "Contemporaneity is the Possession of an Honest Artist: Hamed Sahihi in Conversation with Rozita Sharaf-Jahan", *Art Tomorrow,* spring 2010, pp 86–88.

Parviz Tanavoli

Born 1937 in Tehran. Lives and works in Vancouver and Tehran.

Education

1959 Brera Academy of Fine Arts, Milan
1956 Tehran School of Fine Arts

Solo Exhibitions

2015 *Parviz Tanavoli,* Davis Museum at Wellesley College, Wellesley, Massachusetts
2011 *Poet in Love,* Austin Desmond Fine Art, London
2009 Meem Gallery, Dubai
2006 *Parviz Tanavoli: Recent Bronzes,* Elliott Louis Gallery, Vancouver
2003 *Pioneers of Iranian Modern Art: Parviz Tanavoli,* Tehran Museum of Contemporary Art, Tehran
1976 *Parviz Tanavoli: Fifteen Years of Bronze Sculpture,* Grey Art Gallery, New York
1970 Iran-America Society, Tehran

Group Exhibitions

2013 *Iran Modern,* Asia Society Museum, New York
 Safar/Voyage: Contemporary Works by Arab, Iranian, and Turkish Artists, The Museum of Anthropology (MOA) at University of British Columbia, Vancouver
2012 *Contemporary Iranian Art from the Permanent Collection,* The Metropolitan Museum of Art, New York
2006 *Word Into Art,* The British Museum, London
2002 *Between Word and Image,* Grey Art Gallery, New York
1976 *Modern Iranian Art,* International Art Fair, Basel
1966 *The Rose and the Nightingale* (with Monir Farmanfarmaian), Italian Cultural Institute, Tehran
1960 29th Venice Biennale, Venice
1958 First Tehran Biennial, Abyaz Palace, Tehran

Bibliography

Daftari, Fereshteh, "Redefining Modernism: Pluralist Art Before the Revolution", *Iran Modern,* Daftari and Layla Diba eds, New York: Asia Society Museum; New Haven and London: Yale University Press, 2013.

———, "Passport to Elsewhere", *Safar/ Voyage: Contemporary Works by Arab, Iranian, and Turkish Artists,* Daftari and Jill Baird eds, Vancouver, Toronto, Berkeley: Douglas and McIntyre; and Vancouver: Museum of Anthropology at the University of British Columbia, 2013.

Fischman, Lisa, and Shiva Balaghi, *Parviz Tanavoli,* Wellesley, MA: Davis Museum at Wellesley College, 2015.

Galloway, David, *Pariz Tanavoli: Sculptor, Writer, and Collector,* Tehran: Iranian Art Publishing, 2000.

Pakbaz, Ruyin, and Yaghoub Emdadian, eds, *Pioneers of Iranian Modern Art,* Tehran: Tehran Museum of Contemporary Art, 2003.

Parviz Tanavoli: Fifteen Years of Bronze Sculpture, New York: Grey Art Gallery and Study Center, 1976.

Pocock, Charles, and Samar Faruqi, eds, *Parviz Tanavoli: Monograph,* Dubai: Meem Editions, 2009.

Contributors' Biographies

Fereshteh Daftari

Fereshteh Daftari received her PhD in Art History from Columbia University in New York. Currently an independent curator and scholar, she was previously (from 1988 to 2009) a curator in the department of Painting and Sculpture at The Museum of Modern Art in New York, where, among the many exhibitions she organized, *Without Boundary: Seventeen Ways of Looking,* 2006, featured diasporic artists from the Islamic world. She was the lead co-curator of two exhibitions on Iranian modernism: *Between Word and Image* at New York University's Grey Art Gallery in 2002, and *Iran Modern* at the Asia Society Museum, New York in 2013. In 2012, she curated the first exhibition of contemporary Iranian performance art in Paris and, in 2013, *Safar/Voyage: Contemporary Works by Arab, Iranian, and Turkish Artists,* at UBC's Museum of Anthropology in Vancouver. She is currently finishing a book on the modern and contemporary art of Iran and its diaspora.

Ahmad Karimi-Hakkak

Ahmad Karimi-Hakkak is a Professor of Persian Language, Literature and Culture at the University of Maryland. He has studied in Iran and the United States and has taught at Tehran University as well as several US universities. Author, editor or translator of 23 books and over 100 scholarly articles, he has also contributed to various encyclopedias, most notably *Britannica* and *Iranica*. As a comparatist, he has an abiding interest in exploring intersections between literature and various arts and artistic traditions, Iranian and Middle Eastern as well as Western.

Curator's Acknowledgements

First, I would like to acknowledge my gratitude to Mohammed Afkhami and Maryam Massoudi for entrusting me with the collection, facilitating my access to it, and supporting me in every step of the process. Their assistant too, Jyotika Kapoor, needs a special acknowledgement. I am tremendously indebted to the staff of the Aga Khan Museum, starting with Linda Milrod (formerly Head of Exhibitions and Collections) who was the first person to contact me. My heartfelt thanks go to Henry S. Kim, Director and CEO of the Aga Khan Museum, who has fought for my vision, and his wonderful staff of professionals. I can only name a few: the impressive Sarah Beam-Borg, Dr Ruba Kana'an, Eric Pèlerin, Dr Filiz Çakir Phillip, and Amirali Alibhai. Outside the museum, Rana Javadi, Rose Issa, and Maryam Ekhtiar have been most helpful with information. My special thanks go to Dr Ahmad Karimi-Hakkak for the essay he has contributed to the catalogue. Last but not least, I cannot thank enough the magnificent Iranian artists who have been highly generous with their time and without whom our lives (mine for sure) would be profoundly dreary and hopeless.

Published in conjunction with *Rebel, Jester, Mystic, Poet: Contemporary Persians*, an exhibition organized by the Aga Khan Museum from the Mohammed Afkhami Collection and presented from 4 February–4 June 2017.

Publications: Ruba Kana'an, Head of Education and Scholarly Programs, Aga Khan Museum

The Aga Khan Museum in Toronto, Canada, has been established and developed by the Aga Khan Trust for Culture (AKTC), which is an agency of the Aga Khan Development Network (AKDN). The Museum's mission is to foster a greater understanding and appreciation of the contributions that Muslim civilizations have made to world heritage while often reflecting, through both its permanent and temporary exhibitions, how cultures connect with one another.

The Aga Khan Museum
77 Wynford Drive
Toronto, Ontario
M3C 1K1
www.agakhanmuseum.org

Black Dog Publishing Limited
10a Acton Street, London, WC1X 9NG
United Kingdom

+44 (0)20 7713 5097
info@blackdogonline.com
www.blackdogonline.com

Designed by Mitchell Onuorah for Black Dog Publishing Ltd
Edited by Ruba Kana'an, Aga Khan Museum

All opinions expressed within this publication are those of the authors and not necessarily of the publisher.

British Library in Cataloguing Data
A CIP record for this book is available from the British Library
ISBN 978-1-911164-31-9 (Black Dog Publishing)

Cataloguing data available from Library and Archives Canada
ISBN: 978-1-926473-08-6 (The Aga Khan Museum)

Cover: Ali Banisadr, *We Haven't Landed on Earth Yet*, 2012

Photography Credits

Works from the Afkhami Collection. All images courtesy of Mohammed Afkhami Collection unless otherwise stated.

© Aga Khan Museum, Canada, 2016: p 102
© Shiva Ahmadi, 2010: pp 53–55
© Morteza Ahmadvand, 2015, photography by Mehdi Zahmatkesh: pp 56–57
© Shirin Aliabadi, 2008: pp 59–61
© Afruz Amighi, 2010: pp 63–65
© Nazgol Ansarinia/Green Art Gallery, Dubai, 2015, photography by Negar Arkani: pp 67–69
© Nazgol Ansarinia/Green Art Gallery, Dubai, 2008: pp 71–75
© Mahmoud Bakhshi, 2008: pp 77–79

© Ali Banisadr, 2012, photography by Jeffrey Sturges: pp 81–83 and cover
© Alireza Dayani, 2009: pp 84–87
© Mohammad Ehsai, 2006: p 89
© Monir Farmanfarmaian, 2007: p 91
© Parastou Forouhar, 2003: pp 92–93
© Shadi Ghadirian, 1998: pp 95, 97
© Rokni Haerizadeh, 2012: pp 98–99, 101
© Khosrow Hassanzadeh, 2004: pp 102, 103
© Shirazeh Houshiary, 2005, photography by Dave Morgan: pp 105–107
© Shirazeh Houshiary, 2014, photography by Dave Morgan: pp 108–111
© Y.Z. Kami, image courtesy Gagosian, photography by Robert

McKeever, NY: pp 113–115
© Kiarostami Foundation, 2010: pp 116–117
© Farhad Moshiri, 2007, image Courtesy 2010 Christie's Images Limited, UK: pp 118–119
© Timo Nasseri, 2009: pp 121–123
© Shirin Neshat, 1999: pp 124–125
© Shahpour Pouyan/Grey Art Gallery NYU, 2015: p 127
© Shahpour Pouyan/Lawrie Shabibi Gallery, Dubai, 2014: pp 128–129
© Hamed Sahihi, 2007: pp 130–135
© Parviz Tanavoli, 2005: p 137

Daftari Essay images

© RICHARD SERRA / SODRAC (2016), Canada, image courtesy Gagosian: p 16
© Parastou Forouhar and Stadtgalerie, Saarbrucken: p 21
© Image courtesy of the Kimia Foundation, 2017: p 22
© The Metropolitan Museum of Art. Image source: Art Resource, NY, 2016: p 24
© Khosrow Hassanzadeh, 2007: p 25
© Kevin Sudeith, 2002: p 29
© Y.Z. Kami, image courtesy Gagosian, NY, 2017: p 33

art design fashion
history photography
theory and things

www.blackdogonline.com